D0905268

IMAGES
of America

MANAYUNK

Thom Nickels

ARCADIA

Copyright © 2001 by Thom Nickels.
ISBN 0-7385-0511-0

First printed in 2001.

Published by Arcadia Publishing,
an imprint of Tempus Publishing, Inc.
2A Cumberland Street
Charleston, SC 29401

Printed in Great Britain.

Library of Congress Catalog Card Number: 2001086557

For all general information contact Arcadia Publishing at:
Telephone 843-853-2070
Fax 843-853-0044
E-Mail sales@arcadiapublishing.com

For customer service and orders:
Toll-Free 1-888-313-2665

Visit us on the internet at http://www.arcadiapublishing.com

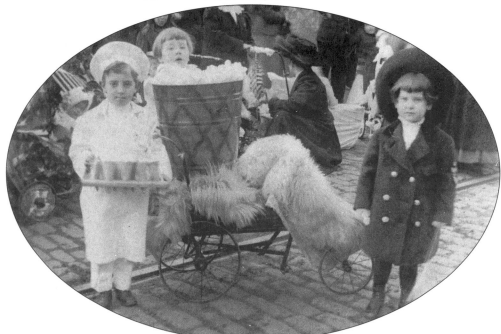

The 1909 Manayunk Carnival and Parade was held to celebrate the town's progress. A brochure commemorating the event read: "To-day Manayunk can boast of its inter-county free bridge, a free circulating library, handsome churches, sound financial institutions, up-to-date stores, an ice-making plant, well-regulated places of drinking, its Manayunk laundry's imposing structure, comforts and conveniences the founders of the town never dreamed of, and its last acquirement, the Manayunk Business Men's Association, under whose auspices its first street carnival is held, and which will be the dawning of a new era of prosperity."

CONTENTS

ACKNOWLEDGMENTS

Talk about Manayunk began when I was a toddler. Perched on my great-aunt Dorothy's knee, I heard about wagons and goats, cobblestone streets, the family horse and stable, and contentious neighbors. There was even the colorful, albeit almost fatal, rooftop tightrope-walking incident I engineered before my second birthday. Apparently I managed to open a third-story window in our house at 4400 Manayunk Avenue and stepped out onto the roof to take in the late summer sun. Dorothy saw me from the garden, a stone's throw away from a fall and an early funeral. "You did an about-face and climbed back inside. We breathed a sigh of relief! Whatever possessed you!" she used to remark.

Recently, while passing 4400 Manayunk Avenue, I tried to guess on which rooftop I had perched. I decided it was the one with the best surveyor's view of the town—the town I was to hear so much of for the next 40 years. Into my late childhood, early adolescence, teens, tumultuous twenties, and beyond, I would watch and listen to Dorothy as she dragged out her out Manayunk scrapbook/diary and begin to read. Even in her last days, when she was infirm and barely able to maneuver through Roxborough's Cathedral Village retirement home, the refrain was always the same: "Let's look at the scrapbook again. . . . I want you to really know . . . Manayunk."

When I started to do research on this book, I tracked down Manayunk-Roxborough historian Nick Myers, who answered my questions and who let me inspect his personal notebooks and photographs. Myers in turn put me in touch with John Kiker, a collector of old photographs whose stockpile of Manayunk images I was to spend weeks rummaging through. John's collection of photographs saved me from jumping from one donor to the next for random piecemeal images. The Kiker compound also held a wealth of documents: a 1911 edition of the *Manayunk Review*, commemorative editions of the *Roxborough Review*, copies of *A Guide to Historic Roxborough-Manayunk* (John Charles Manton), *The Wissahickon Valley within the City of Philadelphia* (Francis Burke Brandt, 1927), and *Memories along the Wissahickon* (edited by Virgil P. McDill and Harry C. Silcox). These books provided much background information and historical detail and were a needed supplement to Dorothy's diaries. I learned much about the trolleys that ran though Manayunk from Fred Bowman of Roxborough.

Not least in the litany of thank-yous is to my parents, pictured on the cover of this book a few hours after their wedding.

—Thom Nickels

INTRODUCTION

The camera makes everyone a tourist in other people's reality, and eventually one's own.
—Susan Sontag

A photograph is a secret about a secret. The more it tells you the less you know.
—Diane Aribus

It would be hard to find another Philadelphia neighborhood as unique as Manayunk. The region is the hilliest section of Philadelphia, with inclines so steep that someone with low energy might find themselves walking slantways like an animated figure. Philadelphia's flat but otherwise easy-to-navigate topography (William Penn designed the layout of the streets) really does put Manayunk in a class by itself. The hills come as a surprise to first-time visitors, as does the old-world look of the canal. Other Philadelphia neighborhoods may boast of European connections, but none—except the Northern Liberties section with its Eastern Orthodox and Byzantine Catholic church spires—is as interesting visually.

Today, Manayunk is a premier Philadelphia community with chic boutiques, restaurants, cafes, and art galleries. The rebuilding of the town occurred in the late 1970s after decades of neglect, which began with the 1929 stock market crash. The Great Depression closed most of the town's mills, clogged the two-mile canal with garbage, rusty pipes, and old tires, and generally had folks comparing the town to an East Coast version of an Old West ghost town.

Manayunk's story is really a triumph of will. Before the Great Depression, there appeared to be no end to the town's prosperity. In 1909, for instance, people from Philadelphia's Main Line flocked to Manayunk's Main Street to visit the Manayunk Farmer's Market or to take advantage of the open-to-midnight shops on a street already crowded with circus-style snake oil salesmen and other amusing hucksters of early-20th-century American life. Central Philadelphia, even today, might be hard pressed to match the activity that this "sleepless" small town exhibited so many years ago.

Before 1683, Manayunk was just a bit of wilderness along the Native American trail from Philadelphia to Norristown. By 1683, Dutch surveyors had arrived in the area and were struck by the hidden nature of the river they were navigating. They named the river Schuylkill, meaning "hidden river." After 1683, English explorers came into the area. One of these early English settlers bought a section of the land along the river from William Penn. The 200-acre tract was known as the Philip Lehman estate. Another English settler, Francis Fincher, purchased 500 acres of land from Penn. In 1691, Wigard Levering purchased another 200, and soon a settlement was born. Wigard Levering's son Jacob built a log cabin on Green Lane and even—whimsically perhaps—added a gin mill. In 1736, Levering built the area's first stone house on Green Lane below Wood Street.

About a mile or two away, another settlement was taking root on the banks of a tributary of the Schuylkill River, the 19-mile-long Wissahickon Creek. (The term Wissahickon, meaning "catfish creek," was coined by the region's Lenni Lenape tribe.) John Kelpius, a German mystic whose goal was to start a Theosophical community in the wilderness, left Germany with his following of 40 monks to escape religious persecution and to greet what they believed was the millennium or a new age of learning, which they thought would occur in the fall of 1694. They arrived in Philadelphia's Germantown section in 1694 but spread out to the Wissahickon Valley shortly thereafter. Kelpius's educated followers studied alchemy, chemistry, philosophy, astronomy, astrology, scripture, and Greek and Latin texts. They built cabins among the primeval rocks of the Wissahickon and formed the Tabernacle of the Mystic Brotherhood. Kelpius's solitary cave on the side of a hill resembled an ancient Jerusalem sepulcher. He lived in the region until his death in 1708 at age 35. Kelpius's cave is still intact; a contemporary

visitor may find it filled with insects and overgrown with shrubbery in the summer months. "No hermit in the African desert was ever more sincere in his flight from the world's temptations or more devout in his communion with the Divine Spirit than Kelpius in his dingy cavern by the banks of the Wissahickon," states *The Cambridge History of English and American Literature.*

A century or more later, Kelpius's cave was used by another Manayunk visionary, Chief Tedyuscung, last of the Lenni Lenape chiefs to leave the shores of the Delaware River. Many historians agree that Tedyuscung was "artful, litigious, and frequently drunk" despite the fact that he was called "Honest John" by neighboring Moravains.

Between the time of Kelpius and Chief Tedyuscung, Gen. George Washington and his troops marched two-step along the Schuylkill with the British in close pursuit. No Revolutionary War battles were waged in Manayunk, but settlers were often badgered or interrogated by both armies.

By 1769, the area was fast becoming an important river port. Long boats—601 feet long and 8 feet wide an pointed at both ends like something out of Thomas Mann's *Death in Venice*—dotted the Schuylkill. Boatman with long poles guided the grain- and produce-carrying boats over murky shallows. The area was developing a character and a personality, yet it still went without a name, though some began to refer to it as Flat Rock because of a large overhanging rock in the area.

In 1817 Ariel Cooley, a Philadelphia architect, proposed that a canal and a dam be built to regulate the turbulent waters of the Schuylkill. Large groups of mostly Irish Americans began digging a canal by hand and built what became known as Flat Rock Dam. The total cost for the project was $60,000. The diggers were known as the Navigation Company, and their completion of the two-mile canal in 1823 brought new life to the area. Although the population in 1817 remained at 60, the benefits of increased waterpower helped Manayunk become such an important manufacturing town that it was called "the Manchester of America," comparing it to the successful industrial British town of the same name.

Capt. John Towers built the first mill along the new canal. In time there were 15 paper firms and textile mills near the freshly dug waterway. A huge clothing fabric mill, Kentucky Jean, manufactured clothes for southern slaves. Later, the first paper plant for newspaper in the country was also founded in Manayunk. Numerous shad fisheries and the building of several new farmhouses like Benjamin Levering's home accelerated the growth of the area.

In 1822, nature's "contribution" to the growth of the area came in the form of a flood. The deluge set into motion what some historians call "the greatest body of water and ice ever known." Canal boats that evoked Noah's famous ark and square-toed, flat-bottomed ships went topsy-turvy in the furious rapids. Townspeople looked on in horror as they experienced the stark reality of the Schuylkill's malevolent side. Indeed, the 1822 flood would be a harbinger of future floods that would often merge the canal with the river or cause the river to rise to the bottom of various bridges over the Schuylkill. The experience taught Manayunkers that industrial progress was no protection against the menace of raging water.

In 1824, with the population approaching 800, Captain Towers and the town council decided that it was time to change the unofficial name of the town, Flat Rock, to something more formidable. At a town meeting, two names came up for debate—Udoravia and Bridgewater.

Bridgewater failed to capture the imagination of the council, whereas Udoravia called to mind the glories of ancient Greece—especially after residents Issac Baird and William J. Brooks conferred with classical scholar Henry Hafnert. Udoravia won hands down, but it was not long before people felt that the name sounded too much like a protracted yodel. At another town meeting, Manaiung, the Native American word for river, was suggested. Before the name was codified, somebody changed the letter "i" to a "y" and the "g" to a "k," and the name Manayunk was born.

In 1825, the first boat of coal came down the canal, followed later by the grandest boat of all, the *Lady of the Lake*, a huge, multicolored ark with a black and red hull and an array of small windows. Another boat, *Independence*, 70 feet long and 12 feet wide, passed through the canal on its way to Norristown.

The new canal brought Manayunk great fame as an inland port. The brochure for the 1909 Manayunk Carnival and Parade stated, "What an inspiration those boats were for the boys and youths, whose highest ambition was to become the owner or captain of one of the boats, especially a lime schooner."

The First Dutch Reformed Church was established in 1826 and was Manayunk's first church. Mount Zion Methodist followed in 1827. With the expanding population came the growth of Manayunk's religious diversity.

Manayunk was coming into its own, although the river still presented a challenge—there was still no way to get across the Schuylkill except by ferry. The 1886 construction of a quaint truss over the canal, the Fountain Street Bridge, came years after Capt. John Towers's vision to build a bridge over the Schuylkill River. He had begun to make such plans in 1828, but his death suspended the project. Towers's vision would not be realized until 1848, when a covered wooden bridge was erected. This bridge was washed away in an 1869 flood when, according to the *Philadelphia Inquirer*, "a canal boat, loaded with coal, struck one of the piers and toppled [the bridge] into the swollen stream." An all-steel Green Lane Bridge, which had a pedestrian pay toll, was finally opened in 1884 and, in 1928, a new concrete bridge was dedicated.

The 1830s were a busy time, as more churches—such as St. John's Catholic, First Presbyterian, and St. David's Episcopal—moved into the area. The eastern branch of the Reading Railroad was also completed. Twenty passengers took the maiden voyage in the stagecoach, a quaint arrangement that was replaced the following year with a small train with a large funnel-shaped smokestack.

Before 1840, Edgar Allan Poe rafted on the Wissahickon Creek. Rafting inspired Poe to write of the area as "one of the real Eden's of the land." He also believed that the beauty of the Wissahickon could only be appreciated from a boat. It is not hard to imagine the poet snoozing on a wooden plank amid the great trees of the Wissahickon forest that many guidebooks of the era say were bent so low over the creek they seemed to be "kissing the surface of the water."

"The Wissahickon should be visited," Poe wrote, "amid the brightest glare of a noonday sun; for the narrowness of the gorge through which it flows, the height of the hills on either hand, and the density of the foliage, conspire to produce a gloominess, if not an absolute dreariness of effect."

No doubt the poet also took pleasure in Manayunk's bars as he cavorted along the waterways, something that poet Walt Whitman was known to have done some years later during his treks into Philadelphia to amble along Market Street or to catch an opera at the Academy of Music. The area along the Manayunk canal has always had an offbeat ambiance. At the turn of the century, Manayunk resident Dorothy C. Nickels, the only daughter of William B. Nickels, president of the Manayunk Business Men's Association and owner of Nickels Hall, remembers how gay men, having no other place to congregate in that unenlightened era, would huddle together on dark street corners. Today, Manayunk's Main Street is as sophisticated as New York or Los Angeles, and gay men no longer have to huddle or hide or even run from lamppost to lamppost in an attempt to keep out of the public eye.

Gypsy families at this time camped near the canal, while during the day they would break up into teams, usually mother and child, and head into the Main Line to pick the locks of the wealthy. At sunset, they would return to the canal to their families and begin the process all over again in the morning.

On June 11, 1840, Manayunk was incorporated as a borough and was no longer considered part of the "Township or Borough of Rocks" (Roxborough). Sixty-nine petitioners, all men, signed their names to the seal, which was approved by the court. Joseph Ripka was chosen as the first burgess, and for 14 years the town gloried in "independence" before it was swallowed up in 1854, when it was annexed by Philadelphia and given the undistinguished classification as the 21st Ward. The incorporation was a peaceful transition, and no record of disagreement or schism exists. Mention of the union in a 1909 souvenir brochure stated only that the "borough continued until the Act of Consolidation went into effect in June, 1854, when Manayunk became part of the extended city."

Polish, Italian, Irish, and German Americans began moving into the area at a rapid pace. The first African Americans settled here in 1830. Churches reflecting the religions of these varied nationalities were erected. It was said that, during the Civil War, Manayunk sent more men and boys to fight for the Union cause than any other small town in the nation. When Lee's forces invaded Pennsylvania in 1863, Manayunk rallied and formed a number of militias to fight for the Union.

One Manayunker who volunteered for the Civil War militia was the English-born James Milligan. Milligan arrived in Manayunk in 1854 with his wife, Hannah, after working in England in a cotton mill and as freelance writer. In 1869, Milligan founded the *Manayunk Chronicle and Advertiser*, with offices at 105 Grape Street. Milligan's newspaper lasted until 1931, 23 years after his death.

Another Englishman, Sevill Schofield, arrived in Manayunk with his family *c.* 1846. Schofield's father, Joseph, was at first in the business of supplying workers to the various mills. Sevill acquired a small yarn-producing mill, Mill Creek. After his father's death, he founded the firm S & C Schofield with his brother Charles. The Civil War helped Sevill become Manayunk's leading industrialist; he purchased the Blantyre Mill in 1862, the Economy Mill in 1865, and built the Eagle Mill in 1884. By the time of his death in 1900, he had employed thousands of workers in his many mills.

Sevill's brother, Charles, lived to see the beginning of the Great Depression and the end of the Schofield dynasty, although the years before the depression were good ones. The mills were booming and people had money. Thousands jammed the streets and came into town in their wagons or buggies from every part of Philadelphia. It was a prosperous time when the Pennsylvania Railroad joined the Reading Railroad, putting Manayunk on the railroad map— the bonus to the town being the new Pennsylvania Railroad or "S" bridge that crossed the Schuylkill and a new train station at Manayunk Avenue and Baker Streets. This was also a time when the streets were cleaned of unsightly debris—some called it a green and black slime—and paved over with Belgian blocks. Sewers were also installed, allowing Manayunkers to inhale without making a face.

Another leading industrialist, Samuel Streeper Keely, began his apprenticeship as a carpenter at age 17. The industrious youth left his employer several years later to start his own business. Keely's life changed dramatically when his former employer drowned while bathing in the Schuylkill River. Keely then acquired his former employer's business and, by 1854, had contracted to build a schoolhouse. When he established a coal and lumber business in the late 1800s, the name Keely was synonymous with Manayunk's building boom. Keely was a staunch member of the Prohibition Party, an alliance that historian John Charles Manton says labeled him "a fanatic" by his contemporaries.

The six-day 1909 Manayunk Carnival and Parade was a high point of the era. William B. Nickels was chief marshal of the parades. Nickels, whose parents had come to Manayunk from Dusseldorf, Germany, used his poetic gifts to entertain audiences with lines like "Is there still no other way / Does all depend on what ones owns / Acres—palaces and thrones?"

During the Great Depression, the answer to that question was a definite yes.

In 1969, the *Philadelphia Inquirer* reported that Joseph Mandarano, a former mill hand and prizefighter, dated the decline of Manayunk from a show of hands in Nickels Hall in the early 1930s. The article reads:

> Over a beer in his Pensdale St. dining room, Mandarano tells you how it was in Manayunk when the community was young, gay, carefree, and having herself one hell of a time. Then came the Depression, unemployment, soup and breadlines.
>
> That's when Schofield rented Nickels Hall. He got up there and reminded us that all during the worst days of the Depression we had worked steady—because he took orders at just a little profit to keep the mills going. . . . He could afford to give us $2 a week. But most of the men voted for the Almighty Dollar. . . . That's what killed Manayunk; those mills never opened again.

One

ALL ABOARD FOR

MANAYUNK

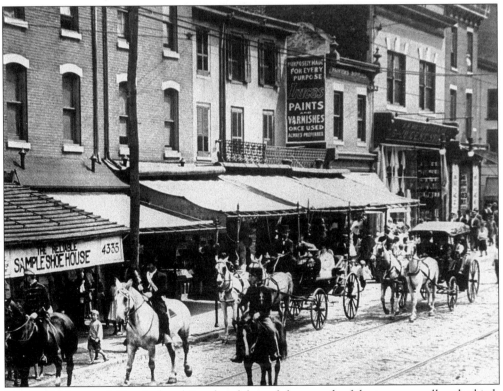

The 1909 Manayunk Carnival and Parade celebrated the growth of the town as well as the birth of the Manayunk Business Men's Association. The stagecoaches shown here on Manayunk's Main Street probably formed the front of the parade. The parade's chief marshall was William B. Nickels, future president of the Manayunk Business Men's Association and founder of Nickels Hall, at 4323 Main Street. The carnival lasted from November 8 to 13, 1909, and had a $50,000 electric light display. Civil War veterans groups such as the Hetly A. Jones Post No. 12 and the Gen. G.K. Warren Post No. 15 marched in the parade.

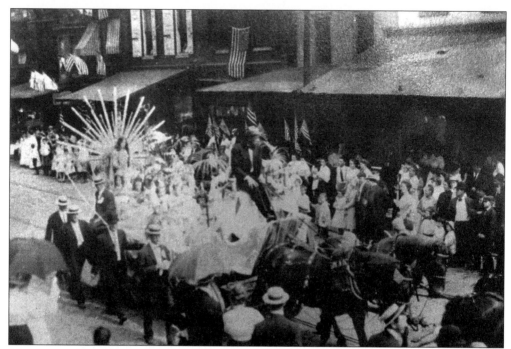

The woman dressed up as a Snow Queen or Madonna is actually holding court before a bevy of small girls. It must have been hot during the 1909 parade along Main Street—the dark parasols suggest a merciless sun.

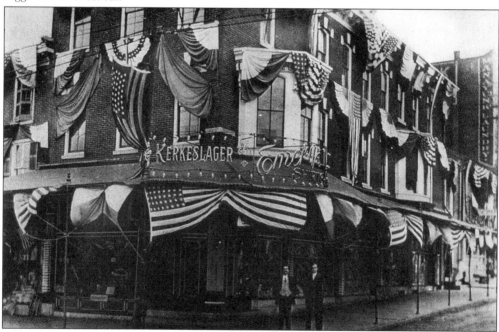

H.F. Kerkeslager's at Main and Levering Streets was the most popular "hatter and furnisher" store in Manayunk in 1909, when life without a hat was unthinkable. At the turn of the century, Kerkeslager's advertised new straw hats at $1 apiece. "Come Early and Get Your Pick" was the store's slogan.

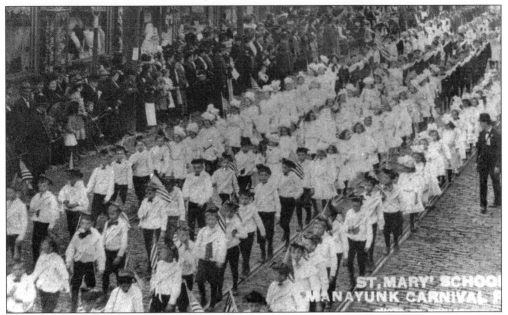

The schoolchildren contingent was a big part of the 1909 parade. First prize was a large silk flag to the school that had the "largest percentage of its enrollment in line." Second prize was a silk flag to the school having the "best order in line." These St. Mary of the Assumption students were taught by an order of Franciscans founded by St. John Neuman. Students at St. Mary's learned German as well as English, although the teaching of German was prohibited during World War I.

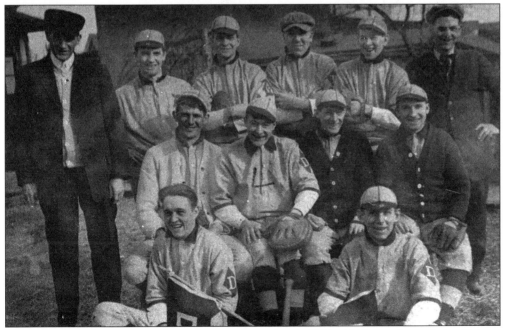

There seems to be a joke making the rounds as these affable 1912 members of the Delmar Athletic Club prepare for a baseball game on the grounds of Roxborough High School. Delmar Club members played both baseball and football.

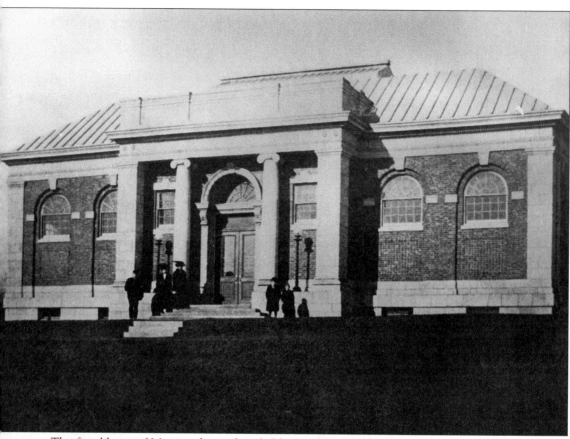

The first library of Manayunk was founded by Jacob B. Smith, a local schoolteacher. In 1854, another small library was founded by James Milligan. Located at Fleming Street and Green Lane, the Manayunk Branch of the Free Library of Philadelphia (pictured here) was designed by Benjamin F. Stevens and opened to the public on February 5, 1909. In its day, the library housed 15,000 books. The library was lit by both gas and electric because of the unreliability of electric light. The building shown here was donated by Pittsburgh industrialist Andrew Carnegie. The Manayank Free Library closed its doors in 1961, and its collection was transferred to the Roxborough library.

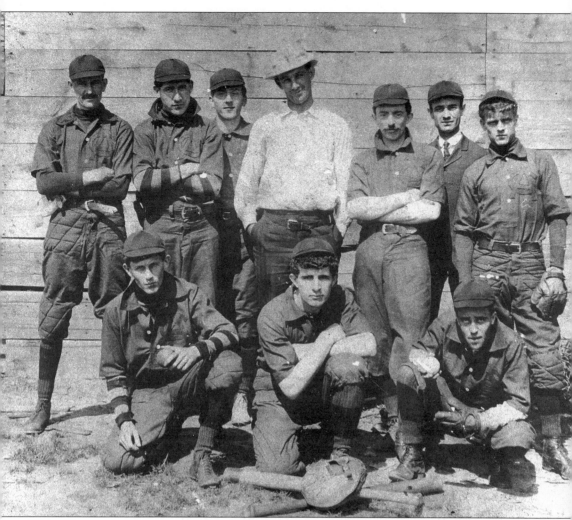

Walt Whitman's American ideal is evident in this *c.* 1915 photograph of a neighborhood Manayunk baseball team. The editor of the *Manayunk Review* might have had this team in mind when he wrote in 1911 in his column "The Sporting News:" "Another win / Hendrick has won 10 out of 12 / Captain Barthold will play short. / Swat Kelly had two timely hits. / Scheld didn't get a chance in left. / Connelly looks to be finished first sacker. / McGill and Kennedy are favorites with the fans. / Chick Rumsey is playing the game of his life. / Snips' return to form is very pleasing to management."

America's love affair with the automobile probably began in the early 1900s. This 1912 photograph shows proud Manayunk car owners getting their jalopies ready for long hauls and excursions. Some of these trips may have included rides along Main Street, which used to be a toll gate street called Manayunk Turnpike.

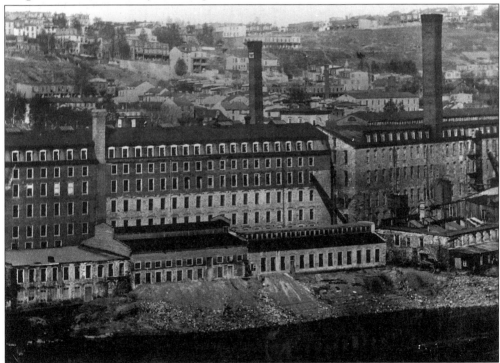

In 1857, Sevill Schofield acquired a small mill on the canal in Manayunk. Later his mills provided blankets for the army during the Civil War. Schofield's mills, shown here c. 1914, were subject to many labor strikes as well as a number of economic depressions in the country. Sevill Schofield died of a heart attack on Christmas Eve 1900.

The Nickels Building was home to this 1920s typical F.W. Woolworth's front window display. In the early part of the 20th century, dancing was almost as controversial as bootlegging. Strict Christian fundamentalists typically raised objections to the Saturday night dances held in Nickels Hall. The flare up of hostilities was sometimes severe but deflated quietly after the crash of 1929.

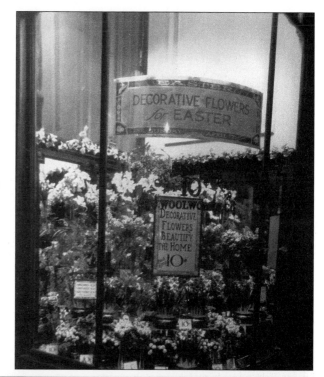

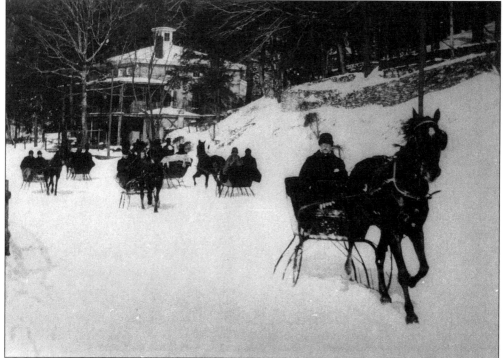

The twists and turns of Wissahickon Drive, just outside Manayunk, must have been hard to follow on a winter's day in 1900. The Childs Manufacturing Company on Main Street was a popular manufacturer of high-grade coaches, wagons, trucks, and wheelbarrows.

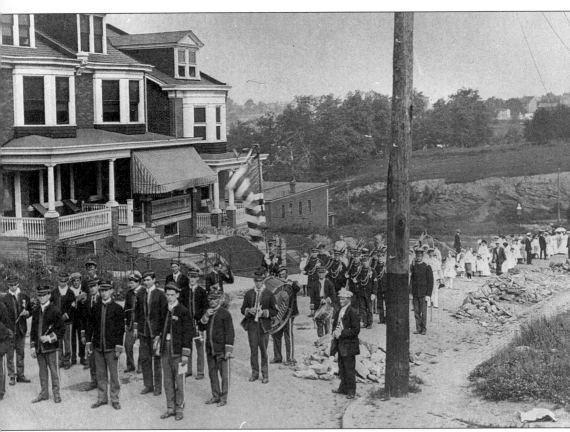

An early-1900s Decoration Day men's marching band, some women, and children dressed in white prepare to march to Main Street. Manayunk in the early 1900s suffered an epidemic of flies. As reported by the *Manayunk Review,* most of the flies came from stables. In 1902, the *Review* reported, "More than 20 citizens have signed a petition to ban stables from residential areas. They claim that 'the clean hay is smelly and dirty horses give off a bad odor.' But the owners of the stables state that the horses 'are needed by the city to pull the wagons on official duties from hither and yon.'"

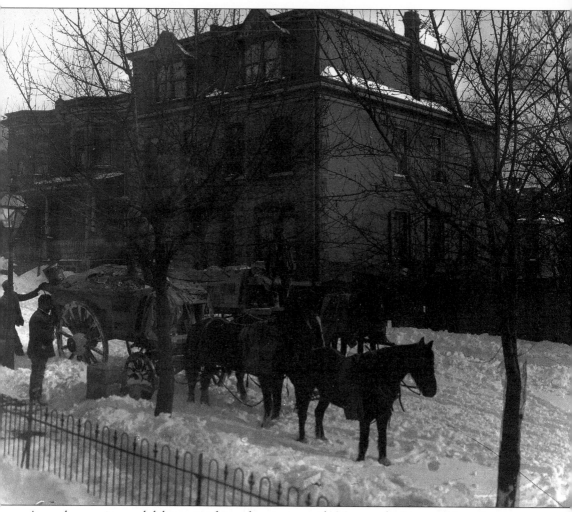

An early morning coal delivery is taking place just outside Manayunk. An even bigger business in the area was the delivery of ice. Ice wagons delivered ice that was sometimes saved from the frozen Schuylkill. Blocks of Schuylkill River ice were kept in ice plants until the summer. In 1904, the warm winter forced Manayunk neighbors to buy their ice from Maine. As reported by the *Manayunk Review* in 1902, the expensive procedure of transporting the ice by boat did not deter neighborhood children from chasing the ice wagons for a free sliver in the summer.

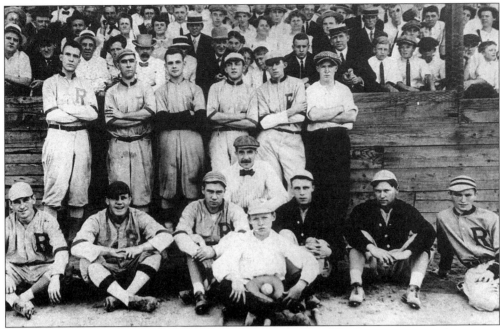

Sandlot baseball teams in the Manayunk-Roxborough 21st Ward area were popular among neighborhood boys. Here, a contingent of 1910 players joins the All-Star fray near the site of an old mill in Roxborough called the Kendrick Recreation Center.

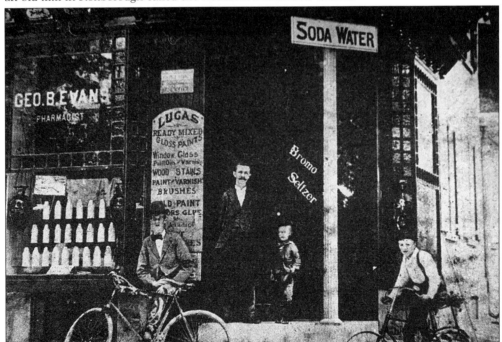

These folks are hanging around the George B. Evans Apothecary at Manayunk and Lyceum Avenues in 1875. The store sold Evans' Blackberry Compound for Summer Complaints (15¢), Extract of Malt (15¢), Pabst Best Tonic (25¢), Evans' Talcum Powder, Evans' Cucumber Jelly for the skin, and Evans' Beef Wine and Iron (50¢).

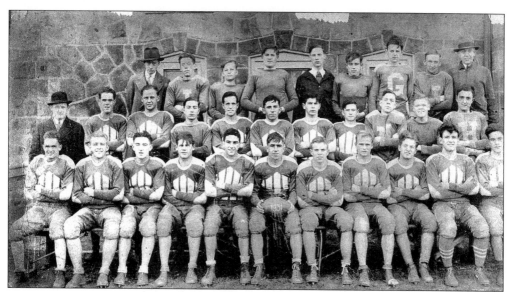

Peer group pressure and comedy must have been flying high among the athlete-students in this unidentified 1920s football team. Notice all the crossed arms and even the strange configuration of "lopsided" shoulder pads on the boys standing in the back row.

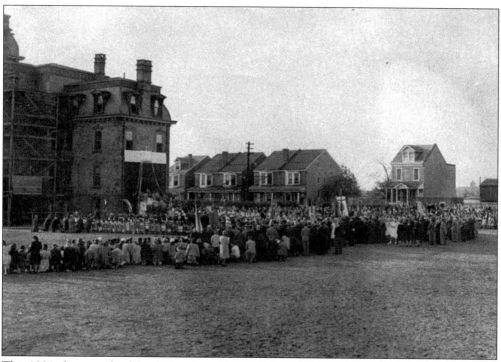

This 1921 photograph of the dedication of Sevill Schofield's mansion as St. John's High School for Boys shows the "public religiosity" of the Manayunk Catholic community. Parishioners from four Catholic parishes—St. John the Baptist (Irish), the Church of St. Mary of the Assumption (German), the Church of the Holy Family (Irish), and the Church of St. Josephat (Polish)—participated in the festivities.

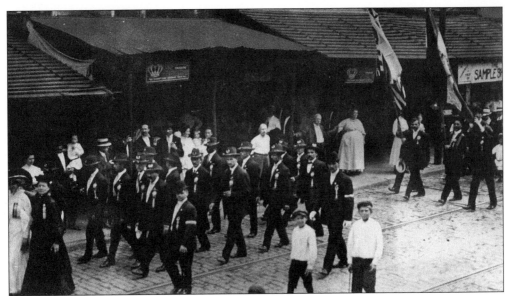

Another "citizens contingent" marches along Main Street in the 1909 parade. Parading works up an appetite; it is a sure bet that many marchers went to Sloan's at 4350 Main Street for a 5¢ sandwich or a roast turkey dinner for 25¢. One of the more popular restaurants in Manayunk, Sloan's sold lamb stew, roast veal, roast pork, or six fried oysters for 15¢. Sirloin steak with vegetables went for 25¢. "We have nothing but the best" was Sloan's trademark.

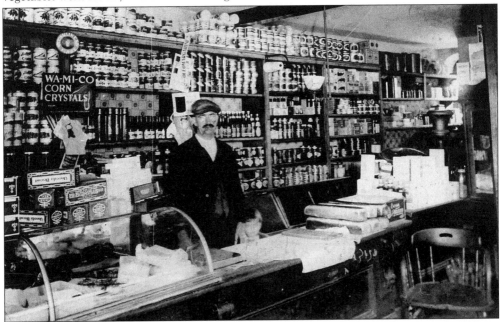

This early-1900s photograph was taken inside the American Store Company at Green Lane and Baker Streets. Popular items sold here included Campbell's soup, Uneeda Biscuits, WA-MI-CO corn crystals, fresh unwrapped loaves of bread, and Dill's Cough Syrup. In 1911, the *Manayunk Review* wrote that a "hard cough simply racks away your vitality and life, causing constant irritation in your delicate tissues; also breeds pneumonia, pleurisy, consumption, etc. For quick relief, sweet sleep and perfect cure, use Dill's."

Manayunk football players warm up on a crisp October day in 1910. In 1911, the *Manayunk Review* carried a regular column called "The Sporting News," which featured news of area teams. There were many sandlot baseball teams throughout the 21st Ward at this time. It was a time when baseball managers resembled bankers or insurance agents in their straw hats, white shirts, or business suits.

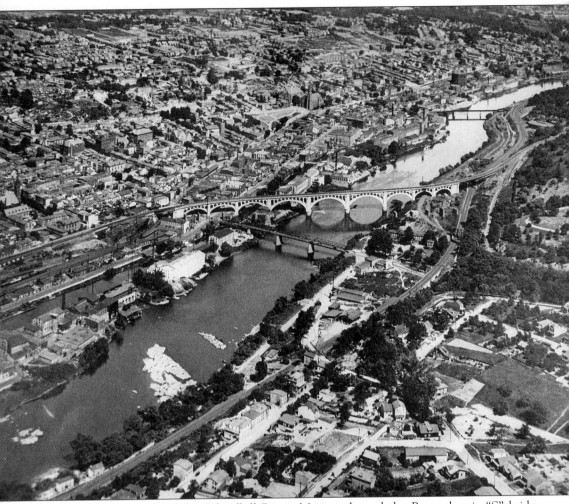

This is a photograph of the Schuylkill River, Manayunk, and the Pennsylvania "S" bridge, c. 1924. The Schuylkill River was discovered by Captain Hendrickson in 1615 when he sailed in his yacht *Onrust*. Since 1615, the Schuylkill has been called many names: Menejackse Kyl, LeRiviere, de Menejackse, and Skiar eller Linde. An early Native American name for the river was Lenn Bikhi, meaning "tree whose bark peels easily." The Dutch coined the name Schuylkill because it appeared hidden in the woods around Philadelphia.

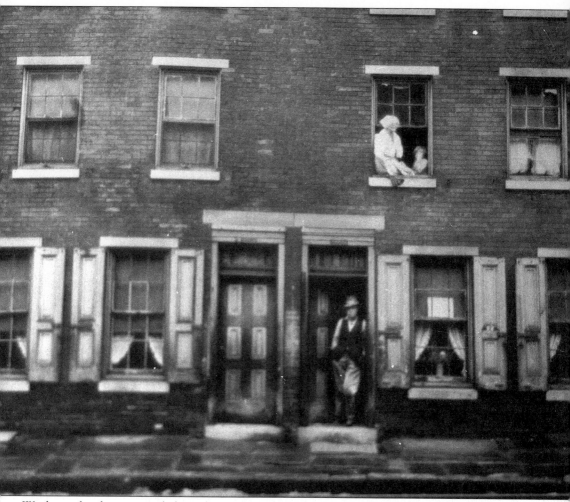

Working-class homes stood along the tracks. Life was hard by the railroad in the 1920s, despite the fact that cement steps were big business. The King Cement Plant (James King, proprietor) advertised in 1909 that they could set cement steps to any house and make them look as nice as marble and as cheap as wood. The company also promised that the steps would never rot. "We give a guarantee of five years with all our work. If it will last five years it is good for a thousand years. If at any time within five years it should break or crack we will make it good."

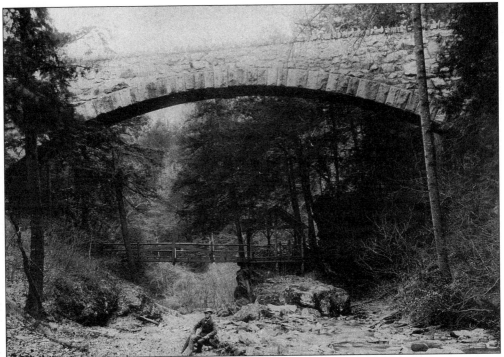

A hiker relaxes at the Creshiem Bridge at Devil's Pool, 1906, where Creshiem creek empties into the Wissahickon. Native American mythology regarded Devil's Pool as a place of worship, where good and evil spirits battled one another. Generations of children, mostly boys, swam in the deep spring water pool and dove from the high surrounding rocks.

Dozens of mom-and-pop variety stores lined the area by the Reading Railroad in 1900. Eisenlorr's was not too far from the Manayunk station. Other well-known shops included James P. McNeil's Ice Cream and Confectionery at 111 Levering Street, Paul G. Pollock (butter, eggs and poultry) at 4376 Main Street, and Mrs. L.F. Guba's at Ridge and Leverington Avenue, a dealer in fancy groceries and provisions.

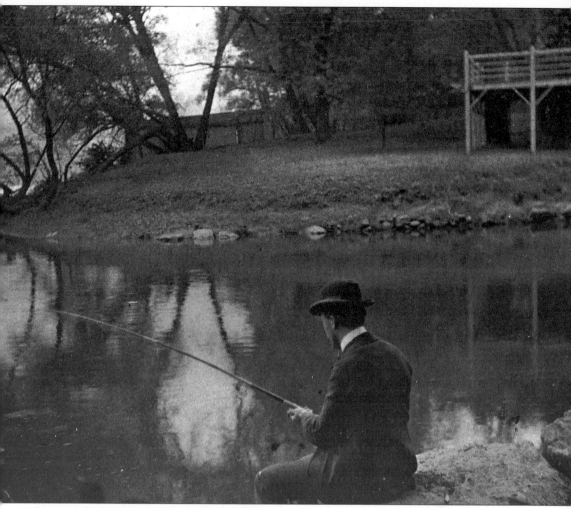

Fishing on the banks of the Wissahickon (a Native American name meaning "catfish creek") was popular *c.* 1919. It is said that catfish were so plentiful in the Wissahickon that they blackened sections of the creek. There were so many catfish that it was possible to catch 3,000 or more a day. Edgar Allan Poe, who was fond of rafting on the Wissahickon, wrote that he often imagined the area "when the Demon of the Engine was not, when pic-nics were undreamed of, when 'water privileges' were neither bought nor sold, and when the red man trod alone with the elk, upon the ridges that now lowered above."

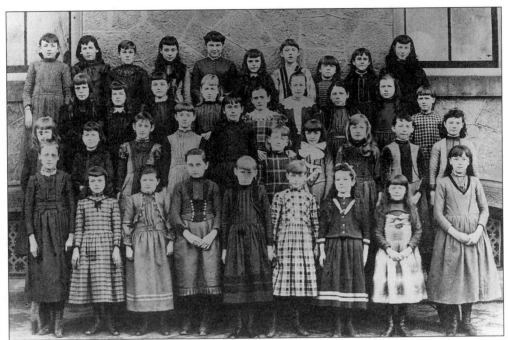

Why are these students not smiling? Looking like adults compressed into the bodies of children, this 1915 graduating class of St. John the Baptist Catholic elementary school calls to mind Edgar Allan Poe's comment that "never to suffer would have been never to have been blessed."

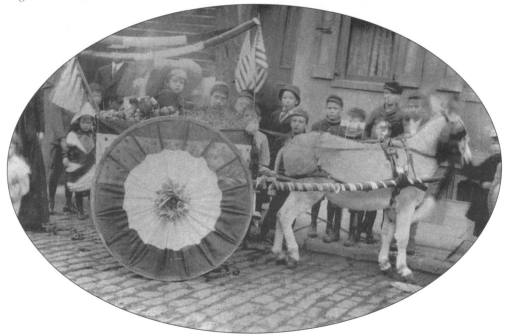

The program for the 1909 Manayunk Carnival and Parade advertised "preliminary lighting and illumination of town by electricity preceding the Carnival . . . General illumination by special electrical designs and streamers . . . Religious services in the various churches of the Ward and the ringing of bells and blowing of steam whistles as the lights are turned on."

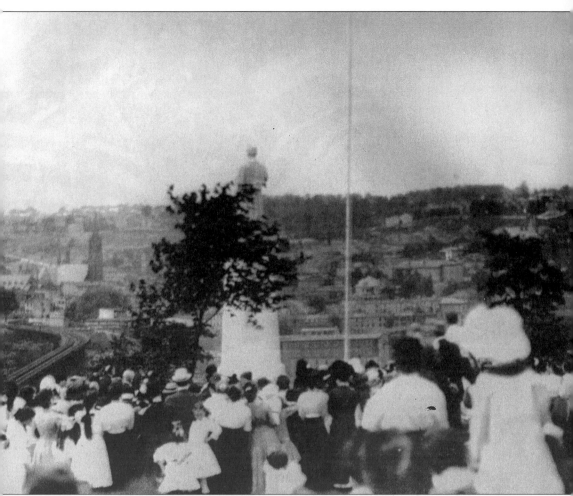

Manayunkers pay their respects to the Civil War dead on May 30, 1901, at the West Laurel Hill Cemetery, West Manayunk (now Belmont Hills). Crowds gather around the Civil War statue commemorating that Manayunk sent more soldiers to the Union front than any other small town in the nation. The Manayunk economy accelerated during the Civil War due to army contracts. The names of Manayunkers who died in the war were inscribed on the Soldiers' Monument in Leverington Cemetery. In 1909, Civil War veteran Thomas Burton, in an interview with the *Manayunk Review*, revealed a scar on his left forearm. "We had a pretty hot experience all through the balance of the war," he said. "This is the only momento I have of the war. A Johnny Reb plugged me in the arm one night while I was on picket duty along the Rappahannock Valley. . . . I had a ride yesterday in an automobile down along the old Schuylkill. It is now a more artistic looking stream than it was when I boated on it, but it no longer looks as it did then. Man's work of art has spoiled nature's work."

Some in the 21st century might call this a lynching, but Manayunk hunters and sportsmen in the 1920s and 1930s had no qualms about leveling game and then hanging their catch out to dry. Here three deer hang by their back legs as a few townsmen gloat.

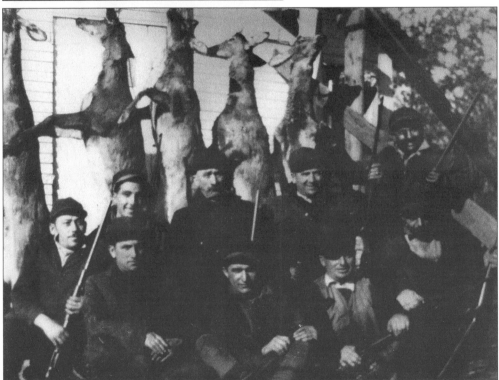

What looks like a czarist insurrection is really a group of 1910 Manayunk hunters showing off the bounty of the hunt. American sporting life at the turn of the century and before included interactions with all sorts of animals. Before he became president, Abraham Lincoln used to officiate at cock fights. Deer are still plentiful in the lush forests surrounding the Wissahickon.

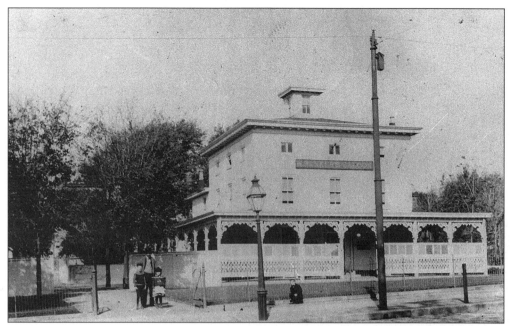

N. Warner's Saloon, located near Roxborough but a popular haunt with Manayunkers in the early 20th century, was one of many taverns along the Ridge Road turnpike. In the late 1800s, stagecoaches traversed Ridge Pike, their drivers stopping at taverns to water their horses. Passengers also took the opportunity to leave the coach for a quick nip or two.

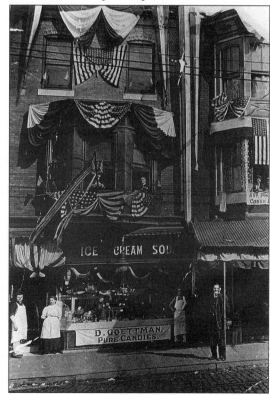

D. Goettman, Pure Candies, at 4357 Main Street, was photographed in 1909. Notice the "candy executive" peering out the second-story window. Goettman's was near G.J. Strickland, a "Practical Horse Shoer" ("Horses Shod According to Nature and up to Art.") Up the street was Martin A. Kehoe, who advertised "Moving and Hauling of all kinds done."

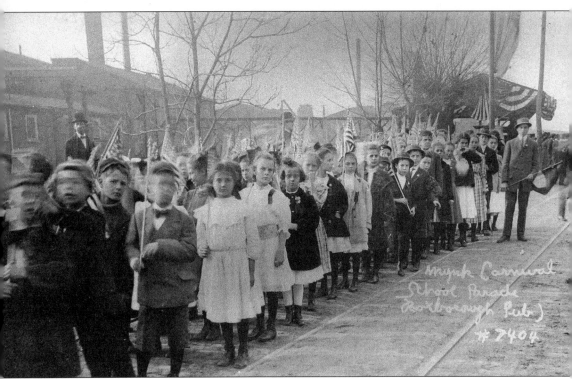

While some Manayunk schoolchildren seemed to take the 1909 parade in stride, other kids—especially boys—took part in a six-mile marathon race. Under the direction of James L. Mulligan, the race was AAU sanctioned. A 1909 brochure stated: "Among the principals will be the best Marathon runners in Philadelphia and vicinity, besides quite a number of local boys of some repute who are going to make an effort to keep a number of the prizes (10 in all) at home. There will also be a dozen hand-organs distributed around the town for the general amusement of the public."

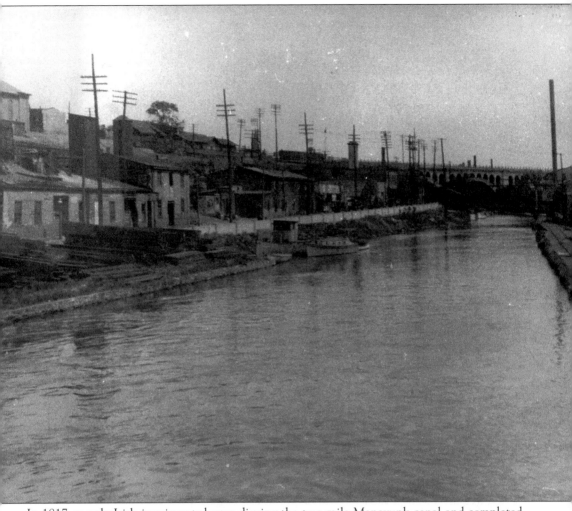

In 1817, mostly Irish immigrants began digging the two-mile Manayunk canal and completed the job two years later. The overgrowth of trees and shrubbery along the banks of the canal has reduced its width over the years, although a redevelopment project currently under way will restore the integrity of the waterway. At the turn of the century, it was the ambition of many Manayunk youths to work at the canal locks and watch the many boats passing through.

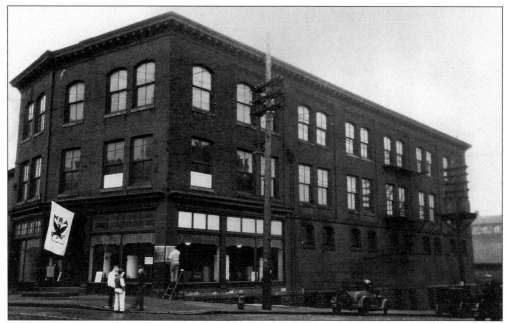

The National Rifle Association (NRA) was a popular 1920s neighborhood organization. The offices of the NRA are probably on the second floor of this busy building on Main Street. At ground level, a worker hangs a new sign for the Philadelphia Carpenter's Community. (The old sign bears a blackened smudge as if damaged by a shotgun blast.) Men dressed in contemporary-looking clothing gather on the corner to observe the goings-on.

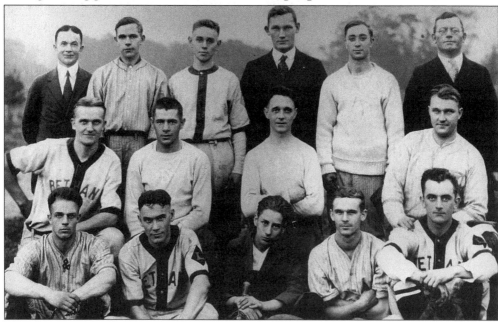

The Bethanien Lutheran Church (German) baseball team seems to be the picture of vitality. The juxtaposition of suits and ties with athletic uniforms was not unusual in 1913. Bethanien Lutheran, located at Martin and Pechin Streets just outside Manayunk in Roxborough, opened in 1849.

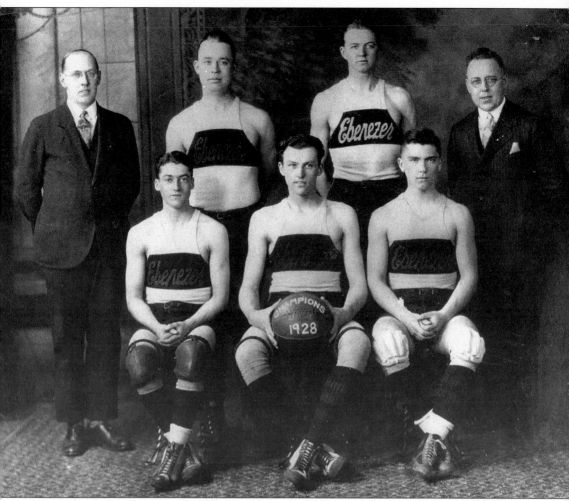

In an era when coaches looked like bankers, it is no wonder that athletes, such as these champion players of the Ebenezer Methodist Church basketball team, found it hard to smile, *c.* 1900. Founded in 1847 and located on Gay and Mansion Streets, the Ebenezer Methodist Church was destroyed by fire in 1975.

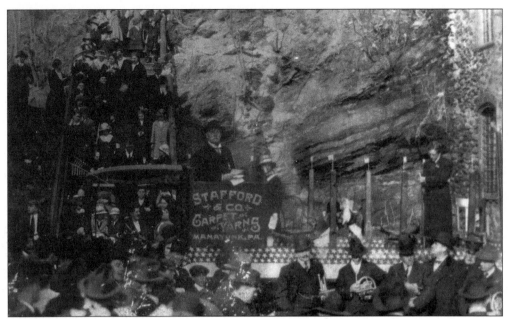

Dedication ceremonies took place on Krams Avenue below Silverwood Street for the opening of Stafford & Company's Little Falls Mill in the 1890s. Little Falls Mill was owned and operated by John and William Stafford. The mill manufactured woolen carpet yarn and employed 39 men, 14 boys, and 22 girls. The original mill was built in 1863. It was refurbished in 1870, 1871, and 1872.

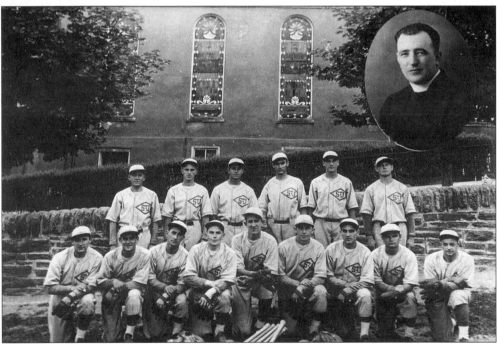

The baseball team of the Church of St. Josephat, a Polish Catholic parish at Silverwood and Cotton Streets, was photographed in 1915. St. Josephat's was organized in 1898 for the Polish Catholic community in Manayunk.

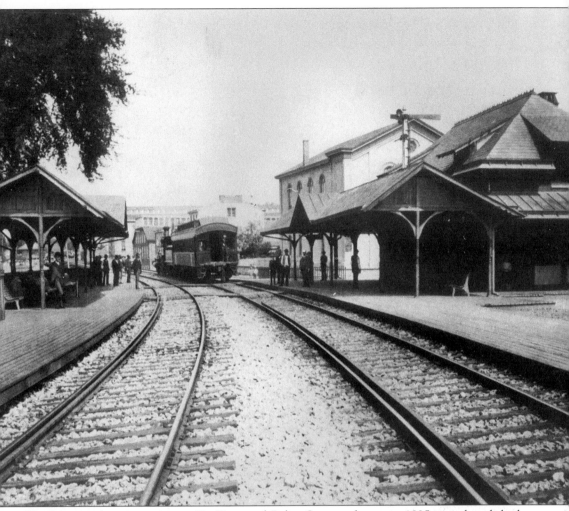

The Manayunk train station at Du Pont and Baker Streets, shown in 1895, was demolished some years ago. Manayunk native Richard Ameye, whose father owned and operated Vick's Groceries on Fountain Street for 60 years, says two of his boyhood friends were killed while trying to cross the tracks. Tragedies like these prompted the construction of the elevated (Reading) railroad line through Manayunk. In a special July 4, 1976 bicentennial edition of the *Roxborough Review*, the trains coming into Manayunk at the turn of the century were described as pulling into the station with clanging bells, rattling wheels, and the hissing of steam. "The conductor would jump off; at night he would have a lantern. If there was freight to be discharged a wagon would be drawn up. Sometimes in the past century cans of milk would be discharged."

This popular Manayunk public school, shown in 1910, burned to the ground under mysterious circumstances several decades ago.

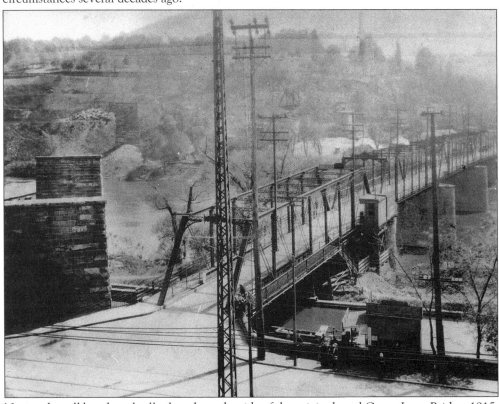

Notice the toll booth and toll taker along the side of the original steel Green Lane Bridge, 1915. The toll was 2¢, although funerals got to cross the bridge for free. Boys often dove or jumped from the bridge into the water below.

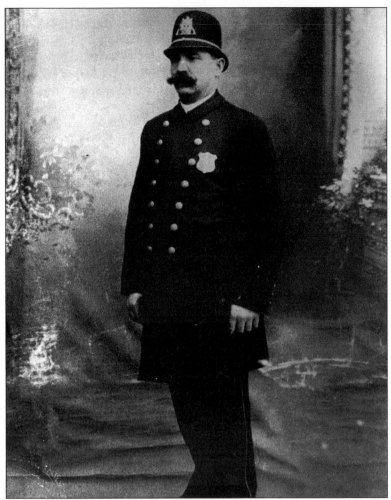

A Philadelphia police officer models the new uniform of the Philadelphia Police Department in 1892. After the Borough of Manayunk was incorporated in 1840, it established its own police force. The head of the force was appointed by a special council. The first jail in Manayunk was founded in 1841. In 1853, the town established the Manayunk Secret Police. By today's standards, the council's minutes regarding the Secret Police sounds like the Pennsylvania version of the Salem witch hunts: "Resolved that the committee on vice and immorality be and are hereby authorized and empowered to employ such number of persons as they may deem proper who shall act under their direction as a Secret Police."

In *Bygones*, author John Charles Manton recounts the murder of 27-year-old Elizabeth Wunder of 124 Cedar Street by her abusive husband, William. On the evening of August 25, 1877, William "went to Norristown presumably to engage in what must have been the chief source of entertainment for a low-paid, overworked laborer . . . drinking in a saloon." He returned home the following morning and got into an argument with his wife, striking her three times on the head. When police arrived, they found her body washed and placed in a 19th-century icebox, a temporary coffin. Her sister Annie Rodgers was in the house during the murder, but Manton suggests that the body was probably washed by a neighbor. On September 27, 1877, William Wunder entered a plea of not guilty. Menton writes: "He was sentenced to five years at hard labor in the Eastern State Penitentiary in Philadelphia. . . . There was no justice for Elizabeth Wunder in 1877, and it is doubtful that she rested in peace."

The end of World War I saw many celebrations throughout Manayunk. On quaint Oak Street, children and adults gather to celebrate the return of fathers, brothers, and sons from the European front. This is probably Decoration Day 1918.

Bethanien Lutheran Church, on the corner of Martin and Pechin Streets, was the first Lutheran church in the area. While technically located in Roxborough, Bethanien was the home church for Manayunk German Lutherans until the construction of Epiphany Lutheran Church in Manayunk. Bethanien was organized in 1845 and opened in 1849.

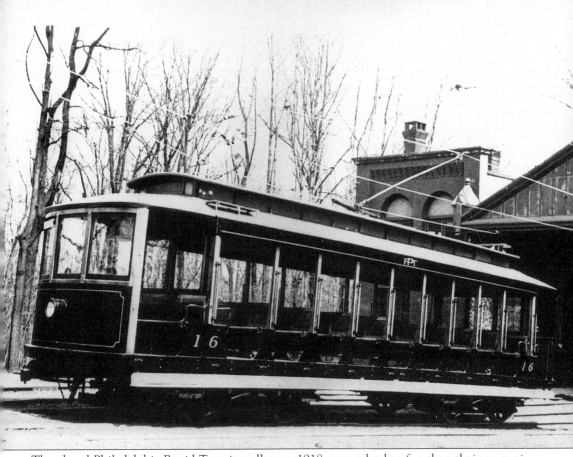

The closed Philadelphia Rapid Transit trolleys *c.* 1918 were a lot less fun than their open-air predecessors. The open trolley cars ran in the summer months. All the sides of these cars remained open, making rides on them extremely pleasurable. Civic organizations and churches would charter these open-air trolleys for events of all kinds. Newspapers of the era were filled with reports of children and adult passengers "making the welkin ring" as the trolley sped along. Accidents from people falling off the running boards and rolling into the street were so common that only closed cars were used.

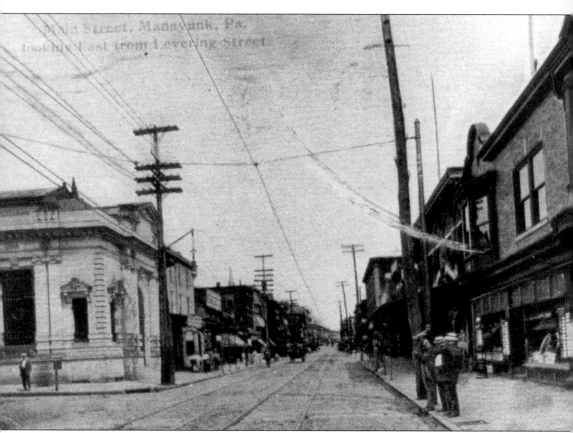

Three Manayunk businessmen in straw hats wait to cross the street, possibly to make a withdrawal. It is probably mid-morning or a lazy afternoon near the Manayunk Trust Building at Main and Levering Streets. Manayunk Trust, which opened in 1890, was one of two banks in the area. Manayunk National Bank opened on August 14, 1871. A 1911 advertisement for Manayunk Trust read, "2 Per Cent on check Accounts . . . 2^1/$_2$ Per Cent Saving Fund . . . 3^1/$_2$ Per Cent Yearly Certificate . . . Interest Allowed on Deposits . . . Acts as Executors, Administrators, Guardians, Assignees, etc."

A young soldier, Bill Nickels Jr., was photographed in 1918 during World War I. On June 26, 1917, Pres. Woodrow Wilson appointed William B. Nickels Sr. to the Local Board for Division No. 14 (Manayunk-Roxborough) in the City of Philadelphia.

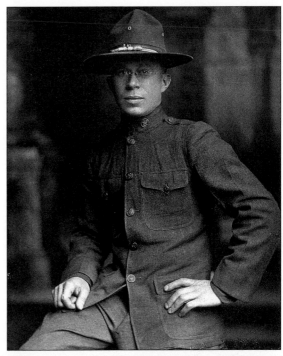

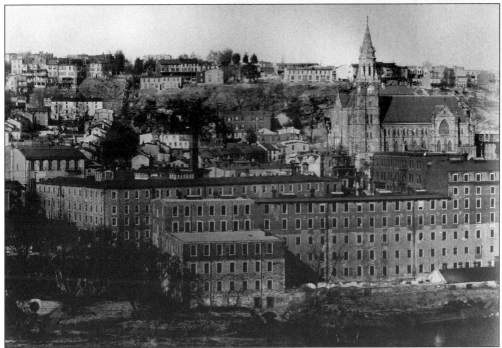

A view of Manayunk in 1913 before the construction of Manayunk (or Pretzel) Park shows houses in the middle foreground that have long disappeared. Prior to 1852, Manayunk used oil lamps and candles for light. Sometime after 1852, a gas plant was built on Main Street. Gas street lamps were installed in 1853. Lamp lighters walked Manayunk streets with ladders at the beginning and end of each day to turn the street lights on and off.

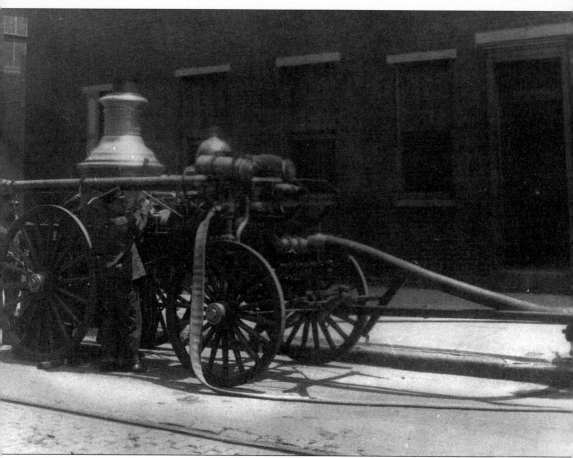

This steam-powered, horse-drawn engine was used to pump water from the fire hydrants. Until 1870, fires in Manayunk were fought by the Manayunk Engine Company, a volunteer fire company located at 4541 Main Street. In 1876, Manayunk's firehouse was moved a few blocks away. In 1928, a new firehouse was built at 4445–4451 Main Street. The causes of many fires at this time were machinery and locomotive sparks, gas explosions, and arson. According to Roxborough historian John Charles Manton in his book *Bygones*, before the consolidation of the city and county of Philadelphia there were many reported cases of violence among competing volunteer firemen at the scenes of fires. For years the rivalry between firemen of Manayunk and Roxborough was a major source of contention.

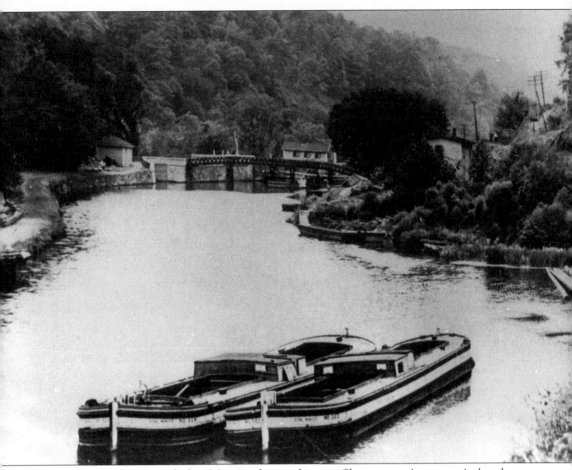

This is an 1899 view of the Manayunk canal near Shawmont Avenue. A brochure commemorating the 1909 carnival describes canal boating in Manayunk as changing drastically in 1870. "Soon after the Philadelphia Reading Railroad leveled the Schuylkill Navigation Company's canal, in 1870, began the decline of boating, and one of the greatest interests the town ever had. Company boats were put on the canal and individual boats 'squeezed out of service.' The decline continued until once busy activities at the locks, the ambition of youths to become owners and the cheering toots of the boatman's horn, become lost arts."

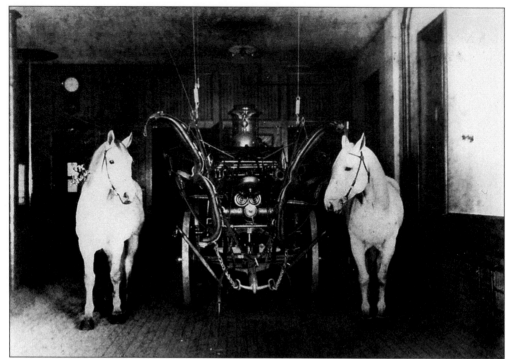

This turn-of-the-century fire truck seems a mere skeleton compared to today's red racing specimens. At that time, the most common causes of fire were defective fuses, coal lamp explosions, spontaneous combustion, and stable fires.

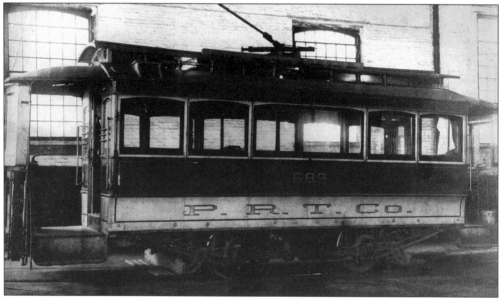

This petite Philadelphia Rapid Transit Company trolley, c. 1910, was an affordable type of public transit. The first electric trolley appeared in Manayunk and in the city of Philadelphia on December 15, 1892. The dawn of electric service sparked a heated public debate on the effects that overhead electric wires would have on the population. The last horse-car trolley line ceased operations in 1897.

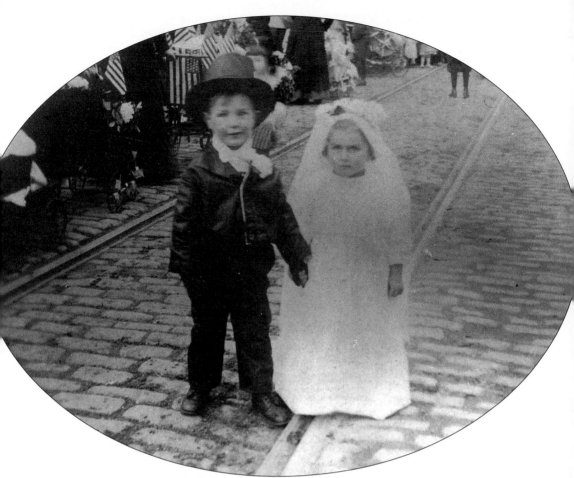

An advertisement for the 1909 Manayunk Carnival and Parade states: "Wednesday afternoon, November 10, will be devoted to the Baby Parade. The parade will form at Green Lane and Main Street, under the direction of the Ladies' Auxiliary, of which Miss M.A. Felin is president and Mrs. M.A. Kehoe is secretary. Special prizes for the prettiest girl and boy, fattest, cutest, longest-haired, smallest, heaviest under one year, most uniquely dressed, [and] best displayed coach. . . . The mothers of the largest family of children in the Ward will also receive a special prize. Every baby in the Parade will also receive a prize."

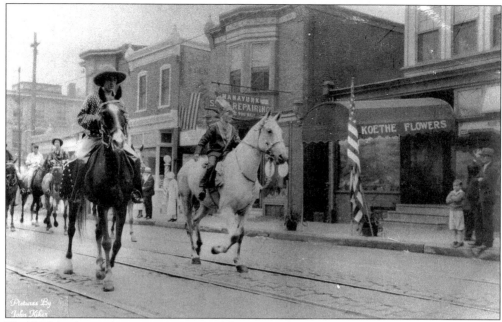

The laid back cavalry invasion pictured here actually consists of 1909 carnival horsemen galloping down Main Street. The six-day carnival, according to the parade brochure, included a parade of decorated automobiles, "a colored band of jubilee singers, a wild man from Africa and clowns." This pre–Civil Rights era carnival also advertised a "grand colored public wedding & bridal procession up Main Street, a colored band, a grand cakewalk, and Georgia minstrels."

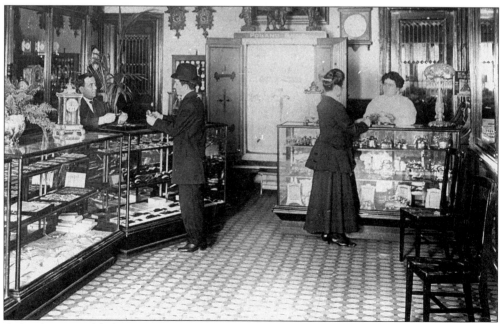

A gentleman and lady visit and "inspect the goods" at the grand opening of Poland Brothers Diamond and Jewelry Experts, 4347 Main Street, 1889. "Our reputation for straight, honest dealing stands beyond reproach," ran one of the store's advertisements in 1909.

48

Samuel Butler's saying, "Thus do we build castles in the air when flushed with wine and conquest," hardly applies to the First Baptist Church of Manayunk, located on Green Lane below Silverwood Street. The congregation was founded in 1851, and the cornerstone of this unique rocklike fortress was laid in 1852.

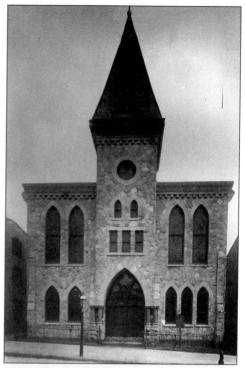

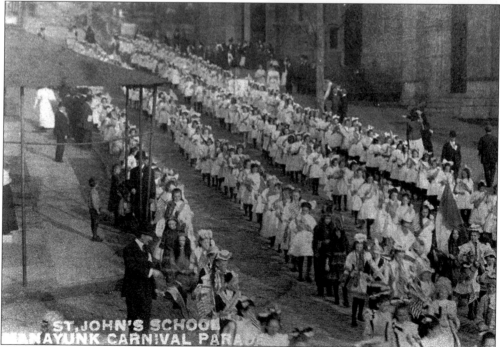

Eclectic costumes mark the St. John's School contingent in the 1909 Manayunk Carnival and Parade. Dressed as Colonial generals, little Marie Antoniettes, or in Native American headdresses, these students marched from Green Lane and Main Street and then to Walnut Lane and around to Green Lane and Main Street again.

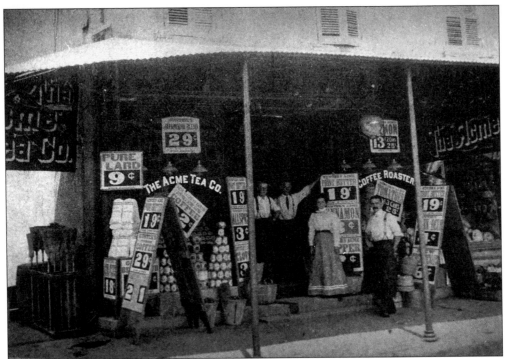

The Acme Tea Company was just one of many small food and variety stores on Main Street in 1900. The smiling workers taking a breather here are undoubtedly feeling the benefits from the turn-of-the-century business boom. The mills had already given Manayunk the nickname "the Manchester of America."

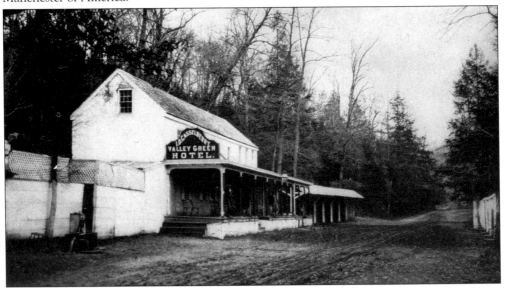

Built in 1850, the Valley Green Hotel (pictured in 1875) is now known as the Valley Green Inn and is one of the most popular restaurants in Philadelphia. Its roots can be traced back to Revolutionary War days; a predecessor of the inn was a hostelry to wayfarers and vagabonds. Similar hotels dotted the valley in the 1700s, but only the Valley Green Inn managed to survive the turbulent birth pangs of the new nation.

Two

The Manchester of America

Long waits between fires probably seemed like an eternity in 1900 as the station horses bucked for release into the open air and a trot around the block. Engine House 12, the first city-owned fire station, was built in 1876 at the corner of Main Street and Green Lane. Here, three firemen while away the hours as the station horse thinks of better days.

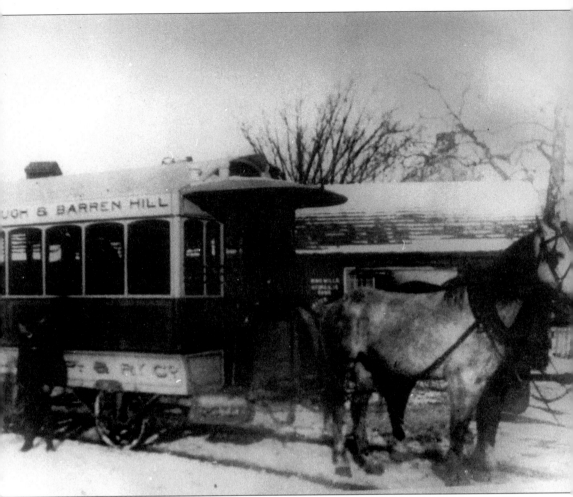

The souvenir brochure of the 1909 Manayunk Carnival and Parade stated that in 1834 the Norristown Branch of the Philadelphia, Germantown, and Norristown Railroad finally extended into Manayunk. "On Saturday, October 18th, of that year, the first cars were run out to Manayunk. The train of four beautiful cars, each drawn by two horses, left the depot at Ninth and Green Streets at 4'o clock, arriving early in the evening. The passengers, numbering 130, filed down to the Fountain Hotel, where lunch was served. The first train of cars drawn by a locomotive through Manayunk passed through the town on Saturday, August 15, 1835, the day the road was opened to travel in Norristown." This photograph dates to 1872.

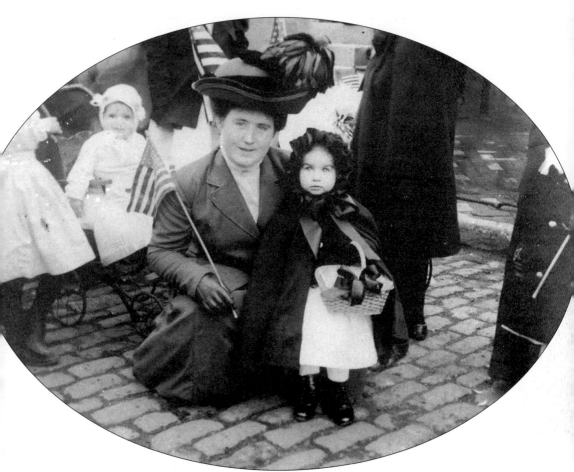

A mother "lowers" herself to Little Bo Peep level during the 1909 parade along Main Street. "To many of those still living in Manayunk," the parade guide stated, "or who were once closely connected with the town, there are some things that will ever be remembered with more or less pleasure. For instance, Hat Shop Hill, now the thickly built up height, which the late James Milligan named Sunnicliffe; the dripping rock, from which for generations the best drinking water in town was procured; the barracks, on the hillside; the dark woods; Buck Hill, and the steamboat landing near old Shur's Lane, with its ice cream gardens."

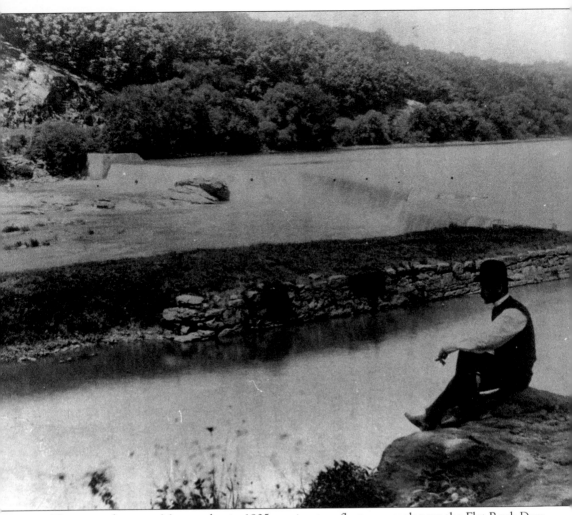

This view of a young Manayunker in 1905 pausing to reflect on a rock near the Flat Rock Dam might be subtitled "Alone Again, Naturally." In the foreground is the beginning of the Manayunk canal with the Schuylkill River behind it. On September 2, 1850, gale force winds and protracted downpours caused more than 225 million gallons of water to be added to the already overflowing Schuylkill. Bridges collapsed, piers crumbled, and tress fell. "Flat Rock Bridge," reported the *Roxborough Review* in 1987, "a covered wooden structure erected in 1811" was knocked over by the broken Conshohocken Bridge. "Flat Rock Bridge then knocked down two more bridges, one at Green Lane and the other at Domino Lane in Manayunk."

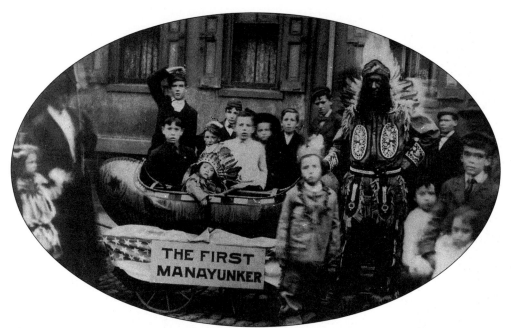

This photograph, showing toddlers and two adults in a deep trance just before the 1909 Manayunk Carnival and Parade, might be subtitled "The Eye of the Camera Always Compels." The event was heralded as "the beginning of a new business era for Manayunk." "This Carnival speaks for itself," the parade brochure stated, "and will long be remembered as one of the most important and successful undertakings ever ventured by the people of this long neglected part of the city."

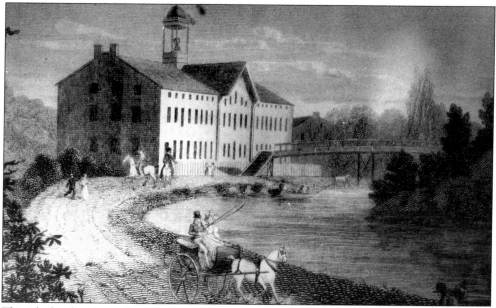

This idealized etching shows how French writer George Sand and composer Frederic Chopin might have looked if they had driven their horse-drawn carriage near the Manayunk canal in the mid-1800s. The representation of gallivanting gentry, a young male hobo with a sack, and a cow attempting to cross the canal is an accurate portrayal of the town's diversity.

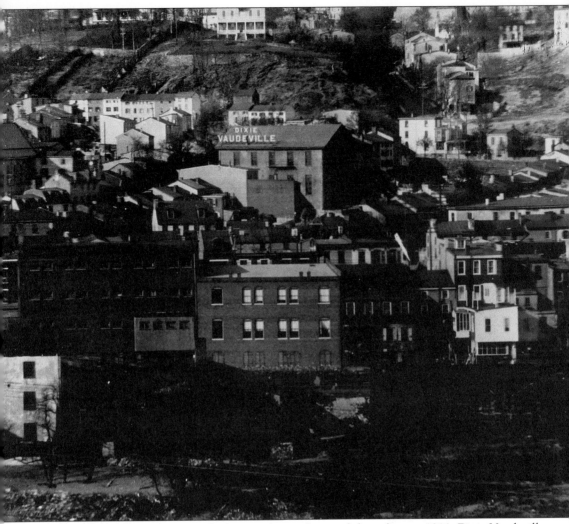

This view of Manayunk from high ground near the canal dates from c. 1911. Dixie Vaudeville was a popular theater in the early 1900s. In 1911, the theater closed for renovations. At that time, the *Manayunk Review* reported, "The policy mapped out for next season will be on an elaborate scale . . . it is the intention of the management to make it an amusement palace on a par with the highest class of theaters." In the early 1900s, many Manayunkers worked more than 14 hours a day at the mills while the women shopped at the Manayunk Farmer's Market. On Sunday's, most Manayunkers listened to the radio. According to the *Roxborough Review*, if anyone in town owned a porcelain bathtub with running water in 1911 they were very fortunate.

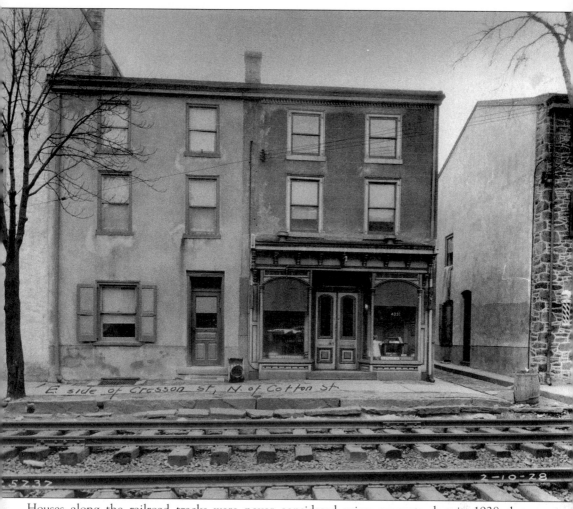

Houses along the railroad tracks were never considered prime property, but in 1928 the *Manayunk Review* advertised a dwelling with eight rooms, a bath, and heater. "We also add that the house is in excellent condition, having been kept so during the lifetime of the owner. The location is ideal; could not get better. We are offering this property at a figure to suit your pocketbook. You can inspect the property at any time you may wish. For prices see James J. Bagle, agent, 4300 Cresson Street." Another property at 4155 Terrace Street, consisting of eight rooms and a bath, went for $16 a month.

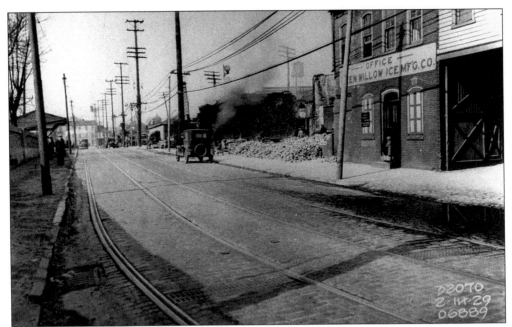

What may look like a bombing blitz is yet another building demolition on the east side of Main Street near Green Lane. Many buildings were leveled during the construction of the elevated, although the Glen Willow Ice Manufacturing Company survived the change. In 1911, Glen Willow advertised that it had pure ice. "The purity of your ice is a matter that you should give careful consideration. There is no dirt or germs in Glen Willow Ice because it is made fresh everyday from double-distilled water."

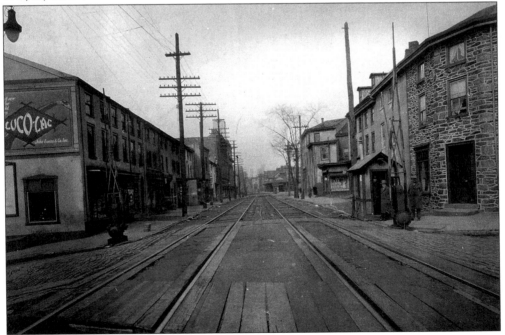

A Reading Railroad gatekeeper and friends in 1928 kill time while waiting for the next train. This photograph was taken before the elevation of the Reading line.

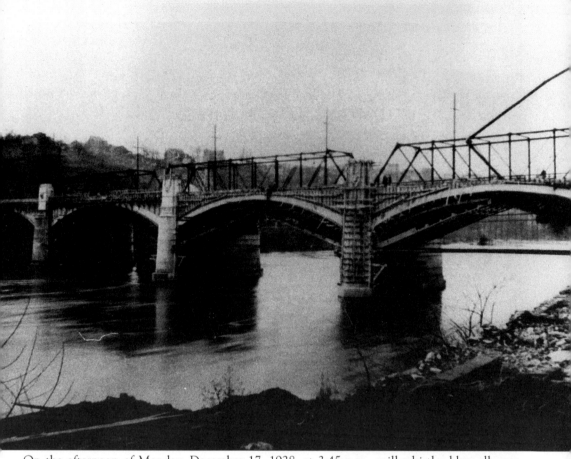

On the afternoon of Monday, December 17, 1928, at 3:45 p.m., mill whistles blew all over Manayunk to celebrate the completion of the Green Lane Bridge. The program began in the center of the bridge and then moved to Manayunk's Empress Theatre from 4 to 5 p.m., where local schoolchildren were shown free "moving pictures." Speakers included the Honorable A. Mackey, mayor of Philadelphia. The $1 million bridge spanned the Schuylkill and linked Manayunk with West Manayunk (now Belmont Hills). On December 18, 1928, the *Philadelphia Inquirer* reported, "The towering structure of steel and concrete . . . replaces an ancient narrow bridge [and is] sufficiently wide to accommodate the heavy traffic." Dorothy C. Nickels, the young girl who cut the ribbon to the bridge, remarked, "How beautiful it is in all its proportions. May its beauty be a symbol of everlasting friendship and good will between the people of Montgomery County, and the people of the city of Philadelphia."

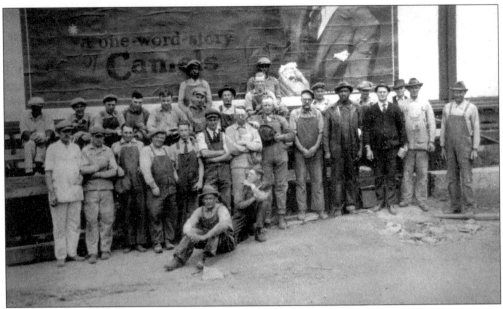

These human workhorses may be thinking about taking a smoke break during the construction of the steel and concrete Green Lane Bridge (completed in 1928) over the Schuylkill River. The ties on some of the workers probably symbolize employment rank.

Manayunk's most famous photographer, David Seeger, took hundreds, perhaps thousands, of photographs of the area. Besides his portraits, landscapes, and building scenes, Seeger took photographs of automobile accidents for insurance companies. Seeger's studio was located on the second floor of a building near the west side of Main Street, near Leverick Street. Area historian Nick Myers remembers being taken to Seeger's studio in 1944 by his parents to pose in his World War II uniform. Myers recalls seeing lots of "prop drapes hanging up in the room."

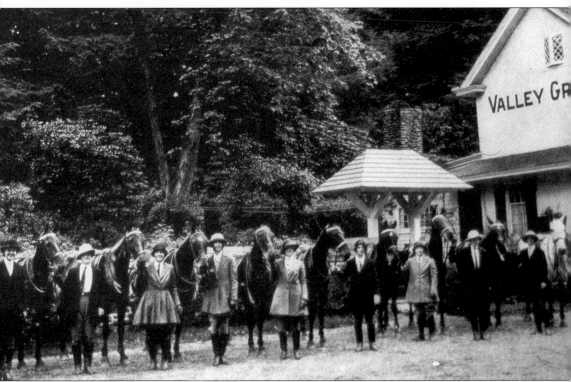

Skilled equestriennes often led the students of many private riding schools over the bridle paths of the Wissahickon. The Valley Green Inn was often a starting and finishing point for these long treks along the upper stretches of the area. The riders in this photograph are probably members of Wissahickon Farms, an exclusive equestrian club that was organized on April 17, 1925. The club was located near the grounds of various estates. Its restaurant, Tally-Ho, was an exclusive members-only attraction. Francis Burke noted in his 1927 book, *The Wissahickon Valley:* "Wherever the start, the arrival at Valley Green is always an event for horsemen, hiker or driver as Valley Green the activities of the Wissahickon horsemen have centered for generations. Here annually in May, on 'Wissahickon Day,' is held a unique parade of horses, city and state, mounted military and fraternal organizations."

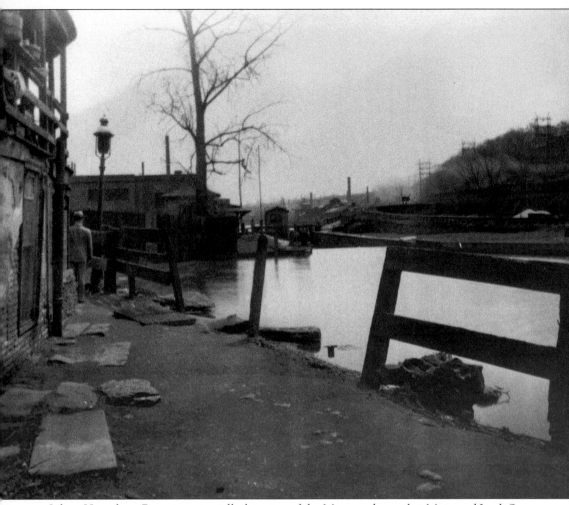

Like a Humphrey Bogart movie-still, this view of the Manayunk canal at Main and Lock Streets in the 1930s evokes the feel of the crash of 1929. Thirty years earlier, the canal had been in full swing under the guardianship of Lenape Lock keeper Capt. Winfield S. Guiles, designated keeper of the Flat Rock Dam Upper Locks on the canal. The legendary Guiles had a talent for being able to foretell the weather by reading the currents in the water.

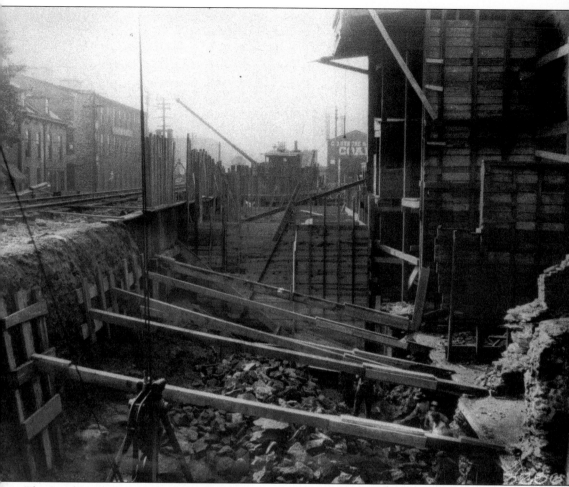

The Reading Railroad elevated is being constructed along Cresson Street in 1928. It is ironic that near the time of the building of the elevated, the country was beginning the Great Depression. Before the depression, the mills were already beginning to leave the area for Center City Philadelphia and large cities on the East Coast. The mills had used up all the available land in Manayunk and could not expand in the area. The Great Depression ended what remained of Manayunk's early-century booming mill town economy, when it was a major producer of textiles, paper, boxes, and iron.

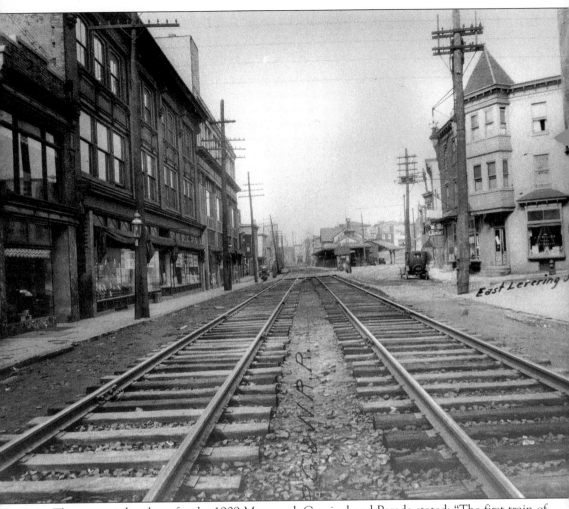

The souvenir brochure for the 1909 Manayunk Carnival and Parade stated: "The first train of cars drawn by a locomotive through Manayunk passed through the town on Saturday, August 15, 1835, the day the road was opened to travel to Norristown. Fifty years later the Pennsylvania Railroad was in operation over its Schuylkill Valley Division, crossing the river over the big 'S' bridge. Local capitalists, with Peter Leibert as President, organized and equipped the Roxborough, Wissahickon, Manayunk and Barren Hill Electric Railway, by which the climbing of the hilly streets became a matter of choice and was no longer a necessity."

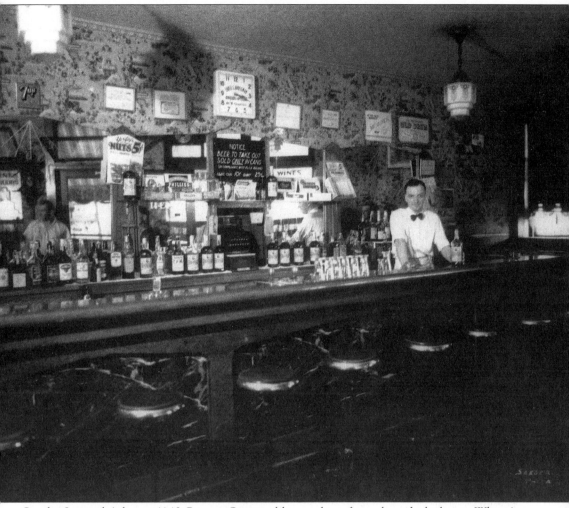

Stanley Lawinski's bar at 4140 Cresson Street sold everything from ale and whiskey to Whipp's Sarsaparilla and Ginger Ale. Also on hand was Haugh's Cooling Claret Wine from the House of Haugh (4351–4353 Cresson Street). "With the thermometer soaring around 95 degrees, there is no better drink for you than a glass of good Claret wine," stated a 1911 advertisement in the *Manayunk Review*. "It is more refreshing than water and less harmful to the stomach. Claret Wine does not chill the system, but produces a mild, invigorating effect that is positively delightful."

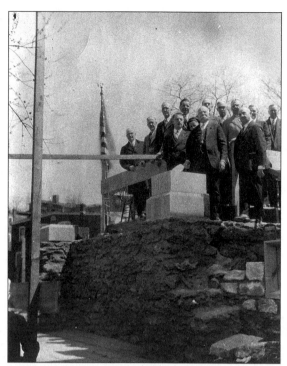

William B. Nickels—owner and founder of Nickels Hall, grand marshall of the 1909 parade, president of the 1915 Manayunk Business Men's Association, and long-term director of the Five Per Cent Building and Loan Association—oversees a crowd of well-wishers during the 1928 cornerstone dedication of a Baptist church at Manayunk and Ridge Avenues.

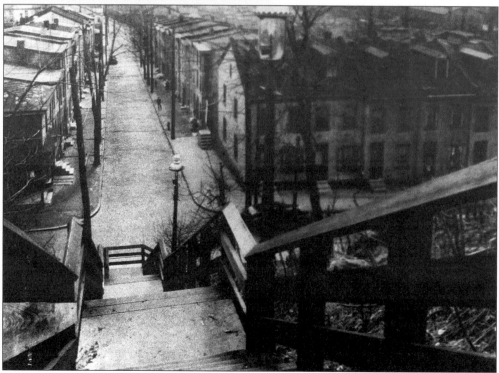

There are more than only 39 steps on this seemingly endless outdoor staircase on Krams Avenue below Silverwood Street, which was once crowded with spectators in the 1890s at the dedication of Stafford & Company's Little Falls Mill, manufacturers of woolen goods.

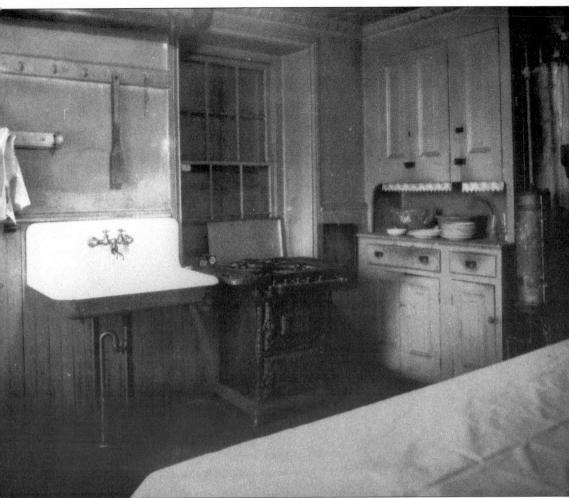

This photograph might as well be a view inside the School of Hard Knocks. This typical Manayunk working-class kitchen in the 1930s makes do with the barest of essentials. Manayunk would have to wait until the 1970s for the various urban renewal projects that would make the town a major Philadelphia attraction. In the early 20th century, Main Street was known as "Newspaper Row," as several Manayunk newspapers—the *Advertiser*, the *Sentinel*, the *Chronicle*, and the *Advance and Review*—had offices there. Mill jobs were so plentiful that adult workers or children could quit or be fired from one mill and within the hour get hired in another.

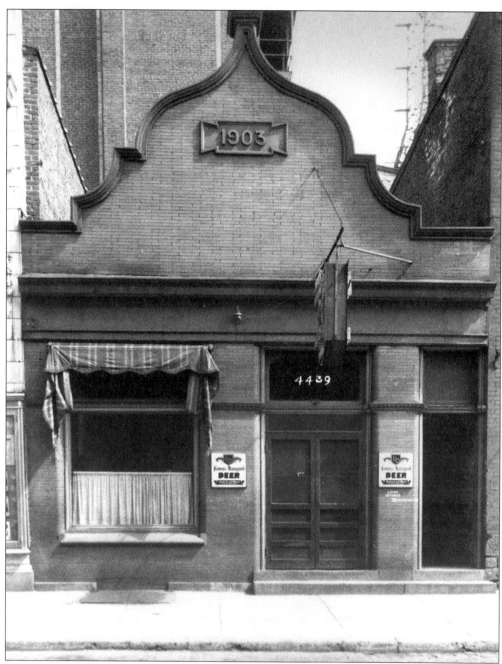

Many alehouses like this stood along Cresson Street, an area called "the Railroad" because of the Reading Railroad. This tidy and somewhat churchlike structure was built and opened for business in 1903. At that time, bars were called saloons, but fortunately saloons were not subject to the city's putting a sign on their front door, as was done with private homes, when the occupants took sick with the measles or scarlet fever or diseases contracted by the many flies and mosquitoes.

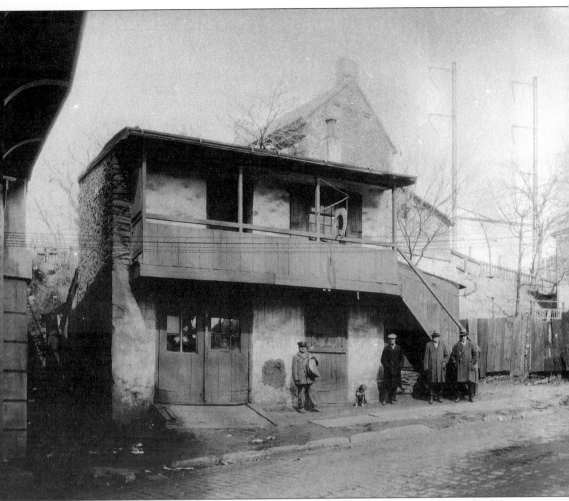

This building, shown in the 1930s, was probably part of an old stable or farm. Notice the muddy, broken sidewalk and the "horse shoer" overhang from an earlier era. The mud here is nothing like it was in 1859. That year, the *Manayunk Star* reported that Manayunk citizens "have had a full opportunity of experiencing the disadvantages of having so few pavements." The newspaper stated that "many streets have been almost impassable" and that some people "had literally to wade through the mire." Some property owners even objected to the novel idea of laying pavements and to show their opposition "to innovation they retain before their doors banks of clay four or five feet in height."

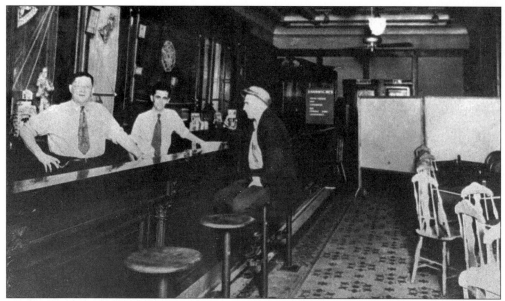

This is another one of the many alehouses that flourished along "the Railroad." Many bars along this stretch of Cresson Street were also betting palaces for sporting contests. These sometimes included dog racing, bulldog fighting, and barroom fights. The *Roxborough Review* reported that one Manayunk saloon owner, Charles Buckly, who kept an old alehouse near Levering Street, as even placing bets "on which glass of ale standing on the bar that fly would alight on first."

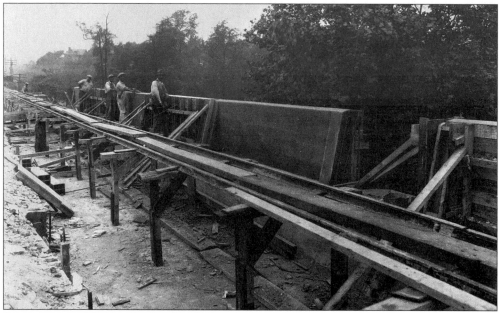

Construction of the Reading Railroad elevated was an engineering marvel *c.* 1927. In just four years, the time it took to complete the project, streets had been redesigned, buildings demolished, numerous pedestrian and automobile crosswalks eliminated, houses raised or lowered in height, and steps moved or rearranged in different geometric patterns. To this day, Manayunkers wonder how this feat was accomplished with a minimum of negative repercussions.

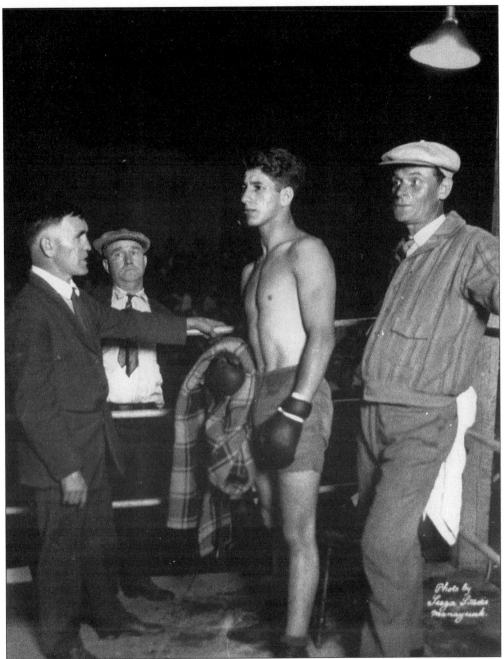

Young Manayunk amateur boxers often went to "Rudolph's Row" in West Manayunk to test their skills. The fights became a magnet for young boys who did everything but swim the Schuylkill to watch famous pros like Benny Bass throw a swing or two. Rudolph's Row was on an open lot between Belmont Avenue and the Green Lane Bridge. It had been named after paper mill owner Sabastian Rudolph, who had built houses there for his employees. Later, when the houses were demolished, the area was nicknamed for Rudolph. Wrestling was also popular in Manayunk. Jessie Massey, owner of a Manayunk alehouse, also trained a group of wrestlers. Massey had a hotel where he housed wrestlers from England before his arranged matches.

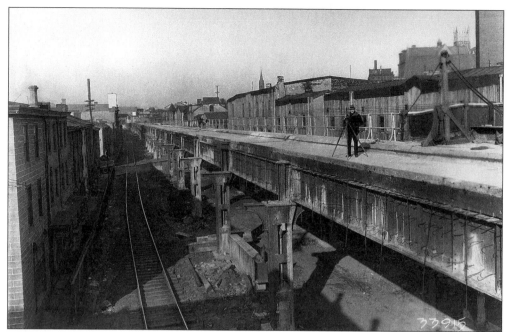

A surveyor measures distances between the (new) elevated track and the old track in 1930, at the halfway mark of the construction of the Reading Railroad elevation project. The project began in 1928 at the Wissahickon-Reading station. It worked its way up to Leverington Street and took four years to complete.

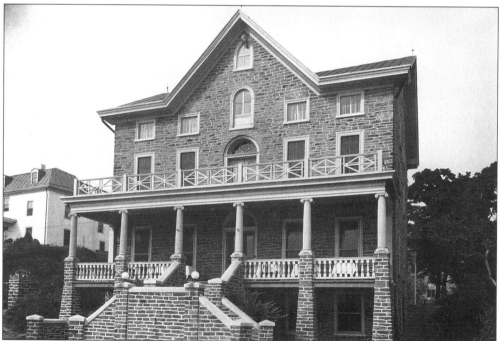

Pictured c. 1939 is the former estate of the son-in-law of John Towers, builder of the first mill in the area and known as "the Father of Manayunk." Located on Fleming Street, the estate later housed the Manayunk Club, a membership-only bar and club that has since disbanded.

This Manayunk 1925 substation generated electricity for trolley cars. In 1925, trolley car rails were called "step rails." Like an ordinary step, one end dropped about nine degrees onto a flat surface. "Gutter rails," or a smooth rail surface with a side gutter that caught rainwater and debris, came later. Within the perimeters of Manayunk, the "Dinky" line was a one-car shuttle that went from Silverwood and Leverington to Baker Street and then out to the Pennsylvania Railroad's Manayunk station located on Baker Street.

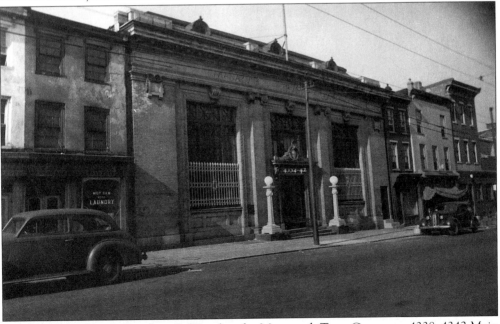

Designed by architects Peuckert & Wunder, the Manayunk Trust Company, 4338–4342 Main Street, opened on July 1, 1912, and closed in 1931. The town's other bank, Manayunk National, opened in 1871 and closed in 1934.

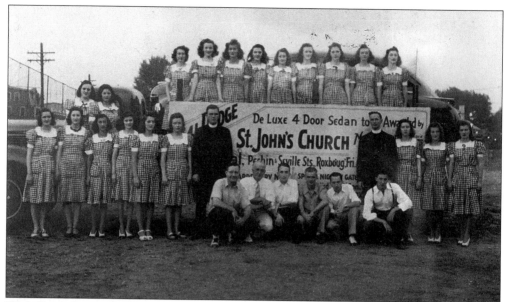

With Frank Sinatra and swing dance in the air, this mostly female 1941 graduating class from St. John's prepares to join the 1941 Manayunk Carnival and Parade. The low percentage of male graduates can be attributed to World War II.

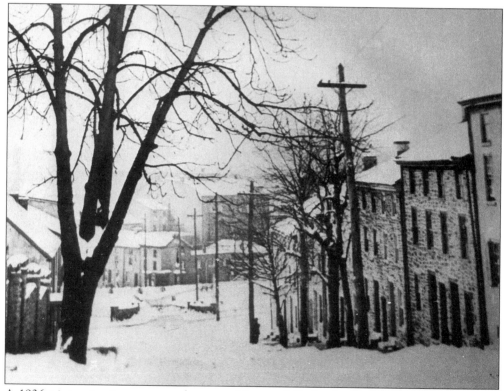

A 1936 winter street scene was taken near Manayunk Park, also known as Pretzel Park. The park was dedicated by Mayor Rudolph Blankenburg of Philadelphia in 1916. Pretzel Park is bounded by Silverwood, Rector, Cresson, and Cotton Streets.

74

All seems quiet on this inconspicuous quiet back street in Manayunk *c.* 1938. With the crash of 1929 long over but with many of the town's mills still closed or forgotten, Manayunk, in its temporary slumber, seemed to be waiting for World War II. That war would claim more than 100 men from the surrounding area.

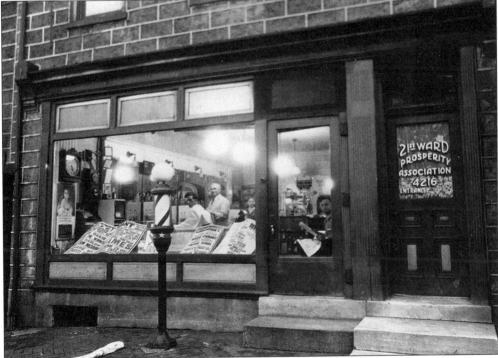

Some Manayunk barbers used boys or their own sons to stand on wooden boxes to lather customers for a shave. This cozy barbershop, shown in the 1930s, was located along Main Street or Cresson Street. In those days, haircuts were 15¢ and shaves a dime.

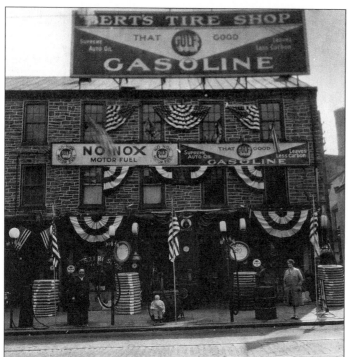

All is peaceful while waiting for the start of the 1930 Decoration Day parade. After the downturn of the Great Depression, smiles slowly began to appear on Manayunk faces, the colors of the street appeared to be brighter, and an almost whimsical attitude gave birth to funny oddities like the miniature toy man displayed here standing beside the American flag.

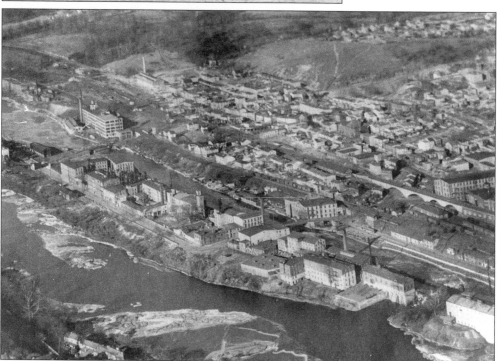

Frozen crab cakes and fish sticks, sold under the Mrs. Paul's manufacturing banner, piled up in huge freezers in Manayunk until the 1960s, when Mrs. Paul's moved to Camden, New Jersey. The 1930s buildings seen here by the canal were demolished to make room for the Arroyo Grille Restaurant, located at 1400 Leverington Avenue.

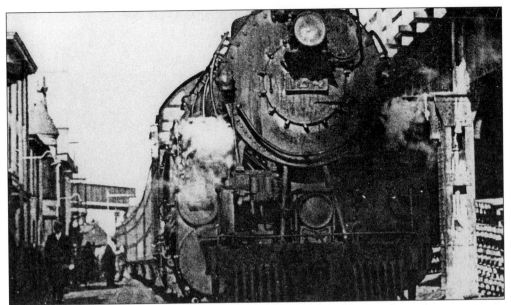

The tracks of the Reading Railroad ran down Cresson Street and were elevated one section at a time. In 1930, the outbound track was elevated first and built on a viaduct. The steam locomotive shown coming inbound from Pottstown is the Gasa Pacific 124, making the traditional Manayunk station stop on the original track.

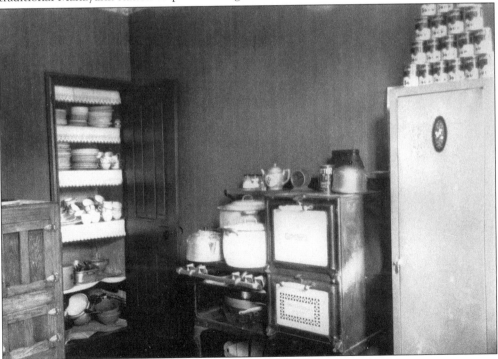

In this late-1930s kitchen, a Warhol-evoking pyramid of Campbell's soup cans towers precariously atop a refrigerator. By the 1930s and 1940s, with most of the mills closed and industry gone, Manayunk was only a shell of its former self. Stores along Main Street were abandoned or boarded up, and the canal was filled with overgrown shrubbery and debris.

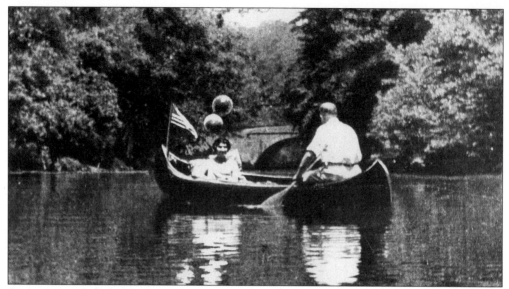

Canoeing on the Wissahickon was a favorite sport, although one had to belong to the Valley Green Canoe Club in order to obtain a canoe. Events, regattas, and contests for canoeists were held on holidays like Memorial Day. Obstacle course races were held and prizes were awarded to winners. The Valley Green Canoe Club was founded in 1909. Writer Christopher Morley wrote that when his mother was a small girl in England, she had a silk lampshade on which were printed the Italian lakes, French cathedrals, Dutch canals, English gardens, and "Wissahickon Drive, Philadelphia, USA."

Shirley Temple's smile may not have been enough to brighten the lives of most Manayunkers in the late 1930s. At this corner bus stop along Cresson Street, three adults and a child linger under a small newspaper photograph of Franklin Delano Roosevelt.

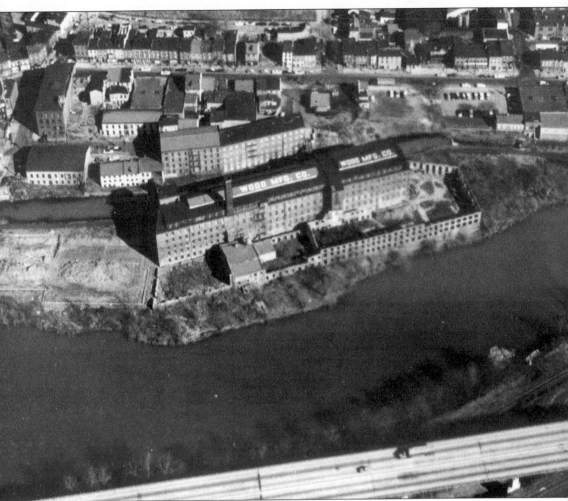

In 1857, this mill, the largest of Sevill Schofield's mills, employed only six people. In 1859, under the firm name of S & C Schofield (for Sevill and his brother Charles), the firm was the first to contract with the federal government for furnishing blankets for the Union army. According to historian John Charles Manton, the mill was rebuilt a number of times after destruction by fire but eventually became so large that it employed thousands of people. One of Schofield's mills, the Eagle Mill, is now a vacant lot. The Blantyre Mill at Main and Cotton Streets is now a condominium.

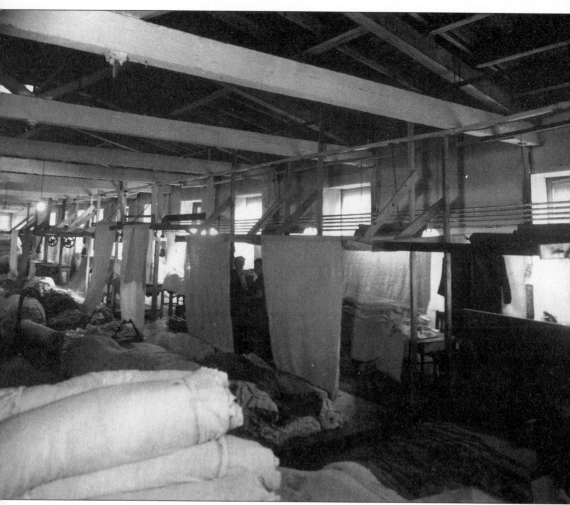

Inside one of Manayunk's many cotton mills, this 1930s photograph shows two employees peeking out from behind an impromptu curtain. Manayunk's earliest settlers had been operators of mills on the Messey and Clyde Rivers, and were spinners and shearers from Yorkshire and carders and weavers from Manchester, according to the *Roxborough Review*. Manayunk's earliest mills were also built to resemble the mills in England. The similarity in architecture gave Manayunk the look of an English village.

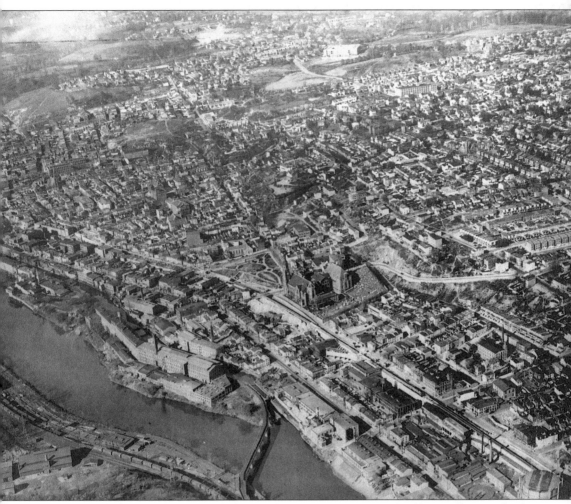

This *c.* 1928 aerial view of Manayunk shows a heavy concentration of mills near the mouth of the canal. In 1859, Lippincott's *Gazetteer of the World* published the following description of Manayunk: "Manayunk is amply supplied with water power and is the seat of extensive manufactories of Kentucky jeans and of woolen goods, three paper mills and a rolling mill. There are six Protestant and two Catholic churches at the place. Population in 1850; 6158; in 1853; 7000."

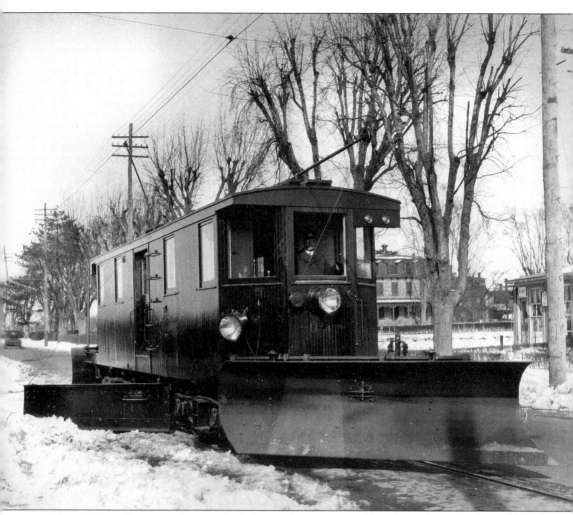

This 1926 trolley snowplow worked the tracks on snowy days throughout Roxborough and Manayunk. The *Roxborough Review* reported that prior to 1924 trolley tracks on many streets, especially Ridge Road, were so bad that cars "heaved and rolled like a ship at sea. . . . It often happened that a car would jump the track and sprawl all over the street; whereupon the conductor and motorman would get out the crowbars, re-railers and other paraphernalia to jack it on again. The passengers would quietly file out of the car, line up along the curb and patiently watch the operation."

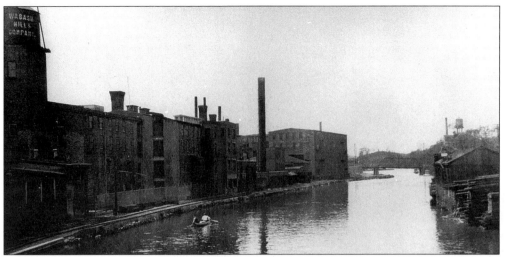

The last big boat to sail on the Manayunk canal did so in 1916. The canal continued to be open for smaller boats, as evidenced in this 1930s picture of two young men making their way up the canal in a canoe. The canal was hand-dug by Irish immigrant laborers in 1819 and was completed in 1823.

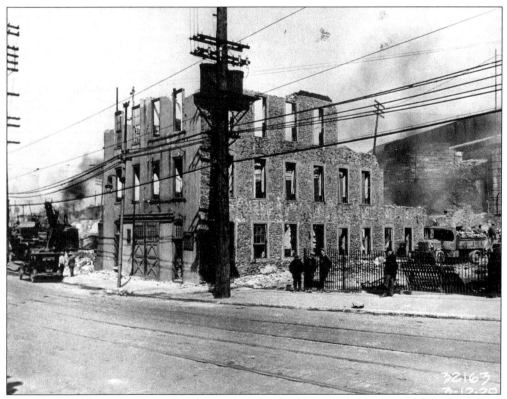

What looks like a war zone is really just another building demolition to make way for the Reading Railroad elevated line. The four-year project, begun shortly before the beginning of the Great Depression, was completed with few injuries and no fatalities.

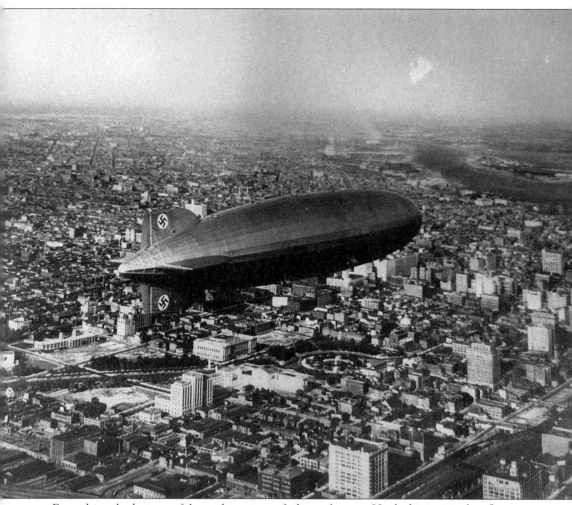

Everything looks peaceful in this view of the infamous *Hindenburg* zeppelin flying over downtown Philadelphia sometime before its crash in Lakehurst, New Jersey. Ruled by drafts and wind currents, dirigibles often had to remain in the air and float around until weather conditions were right for landing. The *Hindenburg,* described by many in those days as a "luxurious flying hotel," had traveled to Lakehurst several times before it eventually crashed there at 7 p.m. on May 6, 1937. Many Manayunkers remember how the dirigible created a sensation in the town as it circled above the Schuylkill before traveling over New Jersey.

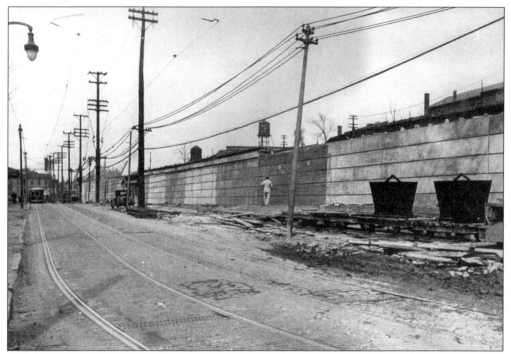

This is one side of the wall that was built along the elevated Reading Railroad tracks along Cresson Street. The wall ran between Green Lane and Leverington Avenue and was used as a support structure, since after the elevation of the tracks a lot of flat ground was left, which had to be filled in or leveled.

Boy shenanigans rule the day in this *c.* 1932 Manayunk dirt parking lot. Manayunk boys since the turn of the century have been noted for their robust hooliganism. The boys in town often dove off the old steel Green Lane Bridge into the waters of the Schuylkill. In the early 1800s, boys would steal rides on the rear steps of mail stagecoaches.

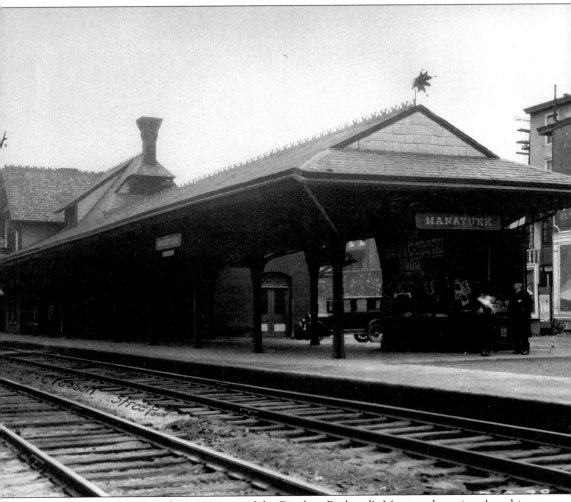

All looks peaceful in this 1928 view of the Reading Railroad's Manayunk station, but this was not the case on Tuesday, October 25, 1892. On that day, a passenger train and a freight train near this site collided head-on, killing 7 and injuring 45 people. The passenger train, the "Pottsville Flyer," was running on the same track as the freight train. Work on an overhanging cliff near the West Manayunk station put the coal- and meat-packed freight train directly in the path of the passenger train. Confused signalmen were responsible for the mix-up that caused passengers to be thrown from the wreckage as an inferno of fire and steam covered the area. Many people in town rushed to the wreck with first-aid supplies. The incident became known as the "Flat Rock disaster." Workers on the scene told reporters at the time that the "injured laying next to boxcar loads of beef made it look like there were no survivors."

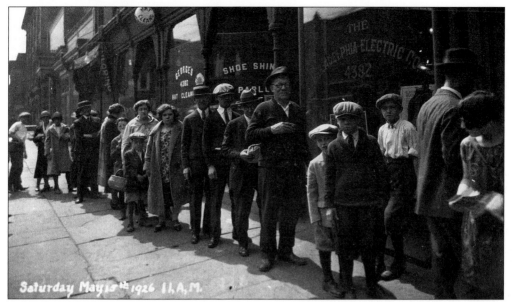

What happened late Saturday morning on May 15, 1926? Why do the adults and children standing in line seem to regard the eye of the camera with both suspicion and awe? Could it be that they were even part of a longer line waiting to buy tickets for an event at the Empress Theater? The Great Depression would not hit until 1929, but already in the faces of these Manayunkers one can detect a look that is not altogether happy.

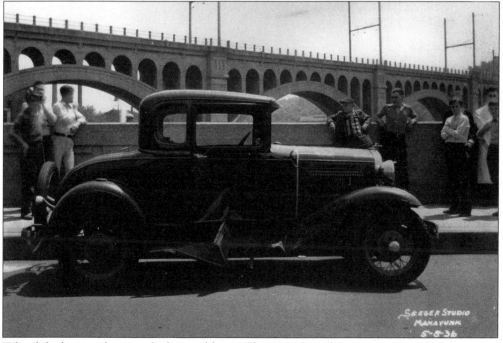

Who did what to whom, and who's to blame? This 1936 David Seeger auto accident insurance photograph shows a group of young men contemplating the darker side of owning an automobile. Crashing on a bridge—in this case the Green Lane Bridge—does little to elevate anyone's mood, despite the altitude and view.

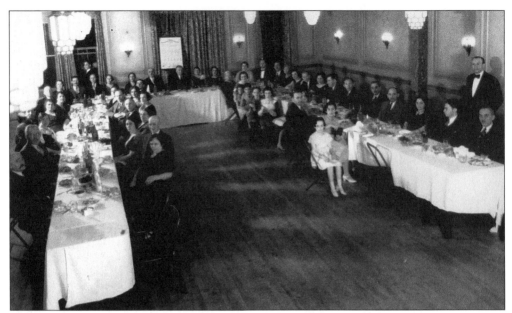

Italian social club members enjoy a celebratory meeting (perhaps in Nickels Hall) in the 1930s. Charles Schofield, brother of Sevill Schofield, announced the closing of the remainder of Manayunk's mills in this room after the start of the Great Depression.

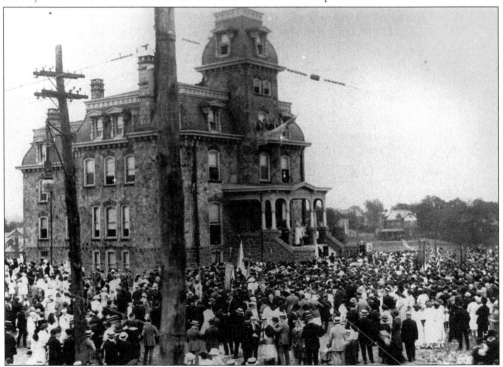

Sevill Schofield's mansion at Pechin and Markle Streets became St. John's Roman Catholic High School for Boys in 1921. This view of the dedication of the building on August 22, 1922, shows the archbishop of Philadelphia in the distance and hundreds of Manayunkers in the foreground enjoying the carnival-like atmosphere.

The Grove, Manayunk's funkiest bar in the 1930s, may not have been visited by Billie Holiday, but it survived many brawls and knicks to its exterior. Bars at the turn of the century posted a "No Ladies" sign at the entrance; the women's entrance was usually off to the side. Beer in 1900 was a nickel and for regular customers there was usually a free lunch at the bar.

Life on the other side of the tracks provided lots of time to chew Red Man. These two gentlemen seem to be enjoying a bit of sunshine and a friendly chat along the Reading Railroad line near Cresson Avenue. Many Manayunk rowhouse owners or realtors in 1911 rented "dwellings" (apartments) for as little as $7.50 a month. Houses with eight rooms, a bath, and steam heat went for $16. Large "For Sale" houses, some with 9 or 10 rooms, sold for $3,200.

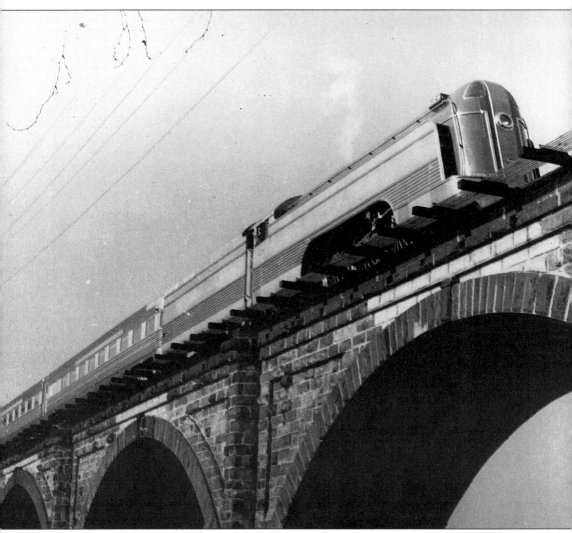

The classic and powerfully handsome Crusader train ran on the Reading Railroad line from 1938 to 1955. Attempts to upgrade Crusader engines failed in the 1960s, when it was estimated that each engine renovation would cost upwards of $1 million. The Crusader's successor was an unimaginative-looking box engine that looked more like a gigantic power tool than the highly stylized engine it replaced.

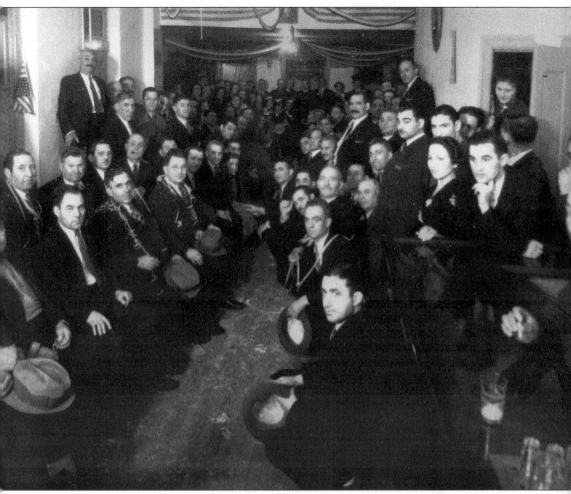

It is crouching room only for this swirling mass of Italian social club members crammed like sardines into Nickels Hall. Built in 1906, Nickels Hall became a popular place to host all sorts of events until the death of William B. Nickels in 1936. In the 1920s, the hall hosted a Saturday night dance club that shocked the town's Christian fundamentalist population. They considered dancing to be an evil on a par with adultery and, as a result, those who disagreed were subject to occasional hostilities.

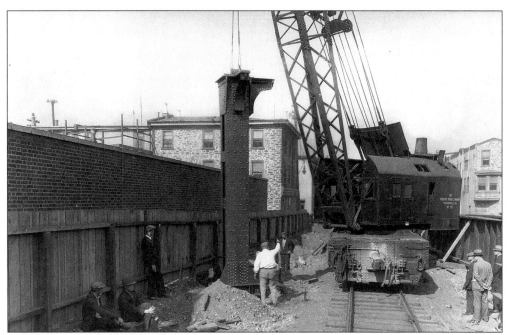

A construction foreman oversees the placement of steel beams along Cresson Street during the construction of the Reading Railroad elevated, 1929. It is easy to see why the men on the left look thoroughly exhausted. They worked the entire summer of 1929 under a hot sun while inhaling thick clouds of dust and pulverized mortar.

An apt title for this 1923 photograph of two young Manayunk men might be "Stealing father's car for a ride into the Roaring Twenties." Manayunk parallels the Wissahickon, an area noted for its country roads and lanes, secret shady nooks, and spectacular vistas.

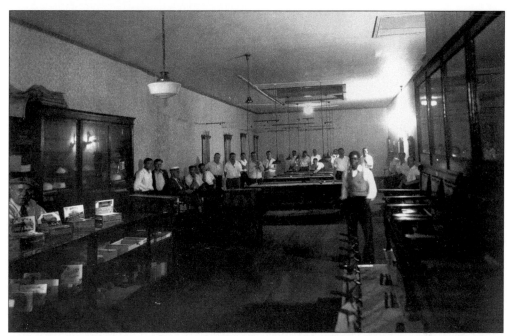

This 1930s pool hall was operated by Nick, the man smiling behind the counter as the entire room, even the shoeshine guys, stand at attention. One can only wonder at the conversations and bantering that took place in this most unilluminated of back rooms.

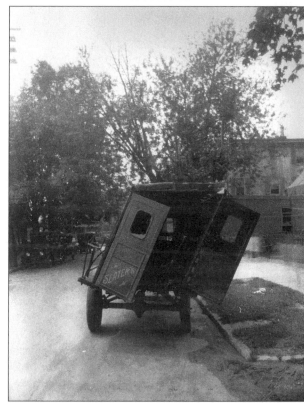

No one will ever know what became of the unlucky milkman who drove his empty milk truck into one of David Seeger's 1926 insurance photograph opportunities. The Slater's truck seems to have been right-angled by something twice its size.

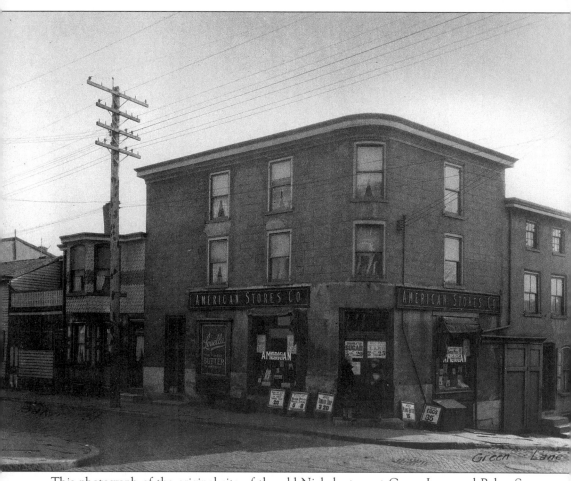

This photograph of the original site of the old Nickels store at Green Lane and Baker Street includes Dorothy C. Nickels, basket in hand, talking on the steps. In her diary of the period, she recalled riding with her four brothers in the family produce wagon to and from early-morning excursions to the wharf at Dock Street in central Philadelphia. About one of these trips, she writes: "We were returning to Manayunk and going up one of the steep hills when my brother John, who was just a child, fell out of the wagon and hit his head on the cobblestones. His head was injured so severely that it caused him to become an epileptic many years later. John's epilepsy was so severe he had to drop out of medical school at the University of Pennsylvania."

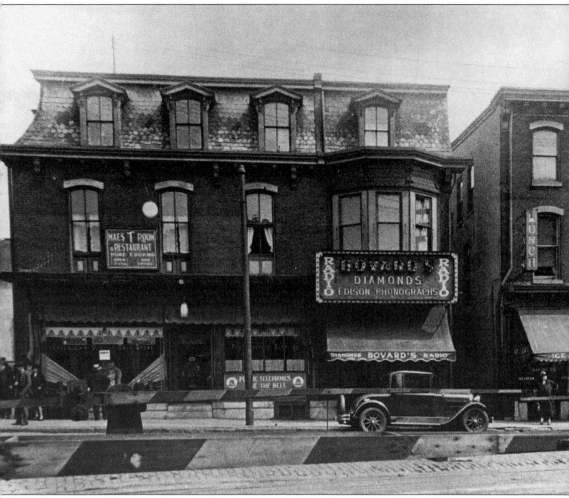

Mae West probably never heard of Mae's T Room on Main Street, but if she had you can bet she would have taken a stroll into Bovard's Diamonds and talked her way into a free eye examination or jewelry repair. Afterwards, she would have taken another stroll into the ice-cream shop and then strolled after a U-turn with her cone to the corner where she would have a chat with the fellas, c. 1933.

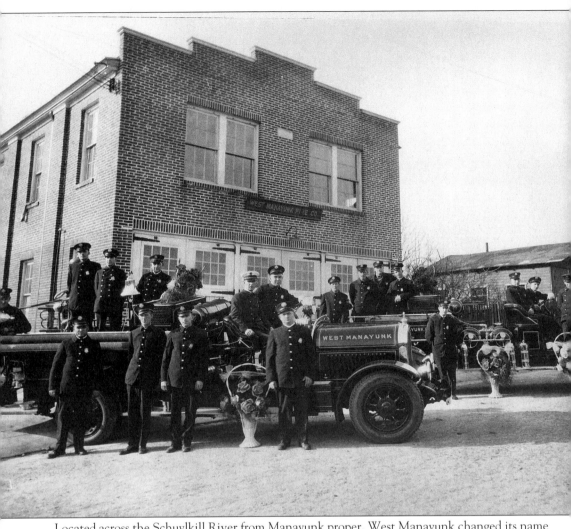

Located across the Schuylkill River from Manayunk proper, West Manayunk changed its name to Belmont Hills in 1950. According to a 1987 historical overview in the *Roxborough Review*, this happened as a result of a slur by author James Michner. Michner, who had written about Philadelphia's Main Line for *Holiday* magazine, referred to West Manayunk as Lower Merion Township's "dark closet." Soon after this, West Manayunk schoolchildren found themselves regarded as social outcasts. Infuriated by the insult, West Manayunkers met in a number of angry town meetings to try and solve the problem. Even Dr. Albert C. Barnes of the Barnes Foundation was drawn into the controversy when he debated Michner. Unfortunately, West Manayunkers felt that the only solution was to adopt Belmont Hills as the new name for their community.

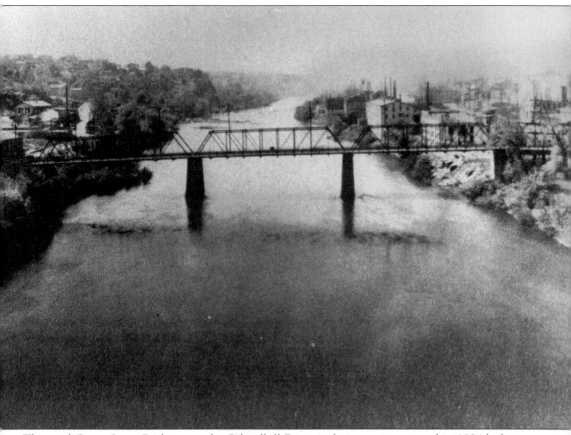

The steel Green Lane Bridge over the Schuylkill River is shown as it appeared in 1924 before its replacement in 1928 with a $1 million concrete span. On October 4, 1869, the worst flood in the river's history occurred. The water level rose so high that the river and the canal became one. A newspaper report of the period recounts how a canal boat, full of coal, broke from its moorings and was pulled into the river. On the boat a young boy refused to follow the captain's example when he saved himself by jumping overboard into a yawl. In shock, the boy was unable to move as the boat crashed into the side of the bridge, where it crumbled and disappeared under the rapids.

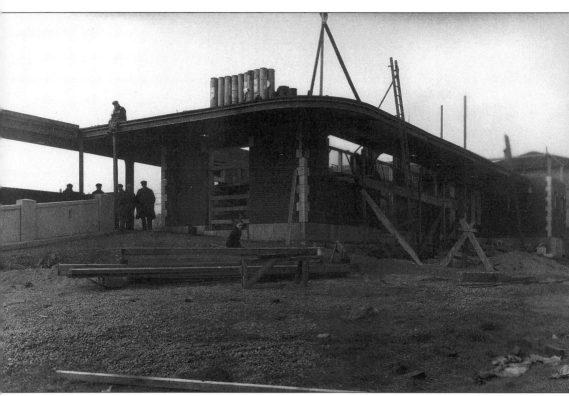

Old Manayunk newspapers reported that "it wasn't Grand Central station but it was the town's railroad depot." Described as a quaint place when completed in 1930, the station had wooden plank benches and a potbellied stove. There was also a telegraph key and a small closet for the ticket agent. Trains pulled in with clanging bells, rattling wheels, and the hissing of steam. The *Roxborough Review* reported that conductors would holler, "All aboard for Manayunk!" even if no one got on.

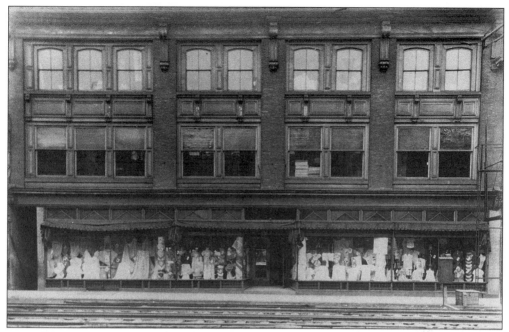

One of the most popular and talked-about department stores in Manayunk in 1911 was Propper Brothers Company on Cresson Street. Advertised as "Manayunk's Busiest Store," Propper Brothers sold ladies' summer dresses for $1.98 and $2.50. Men's Lisle tan finish socks went for 10¢ a pair, two-piece suits sold for $3.98, and children's "barefoot sandals" were tagged at 39 and 49¢ a pair.

The Franklin Delano Roosevelt campaign posters on the second-story windows over this barbershop on Main Street indicate a renewed sense of optimism after the 1929 crash. Here, neighbors converse, a dog eyes life on the sidewalk, and a woman in a doorway eyes the eye of the camera, c. 1935.

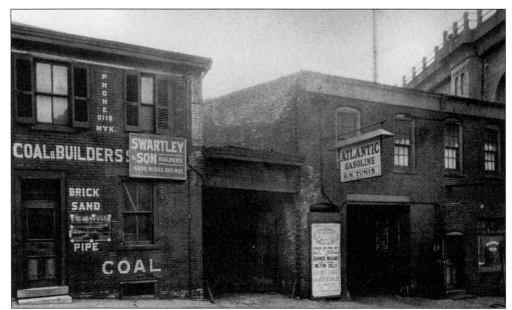

There is little glamour in this 1928 view of Green Lane and Cresson Street. William Bernard owned this humble coal business. Coal was often sold with grain. Another coal business on Cresson and Jamestown Streets, John Hare & Son, advertised that they only handled the production of the best mines and that coal from the West was prepared "especially for us." "The best is the cheapest," a Hare & Son 1909 advertisement read. "We handle only the best, and our prices are right for a first-class article."

Samuel S. Keely was born on July 12, 1822. At age 17, he studied carpentry under John Lewis and, in 1844, he married Jane McFadden, the daughter of a Manayunk contractor. Keely built a number of mills. He established a lumber business (pictured here) that by 1891 had become the largest and most profitable in the region. Keely was also an elder in the Presbyterian church. He died of pneumonia on January 13, 1899.

Three

THE HARDER THEY FALL

Manayunk has always been a racial and ethnic melting pot: the English came in the 1600s; the Dutch, Scotch-Irish, and the Germans in the 1800s; the Polish in the 1880s; and the first African Americans in the 1830s. This 1929 African American pool hall by the Reading Railroad tracks is indicative of the diversity of the railroad area.

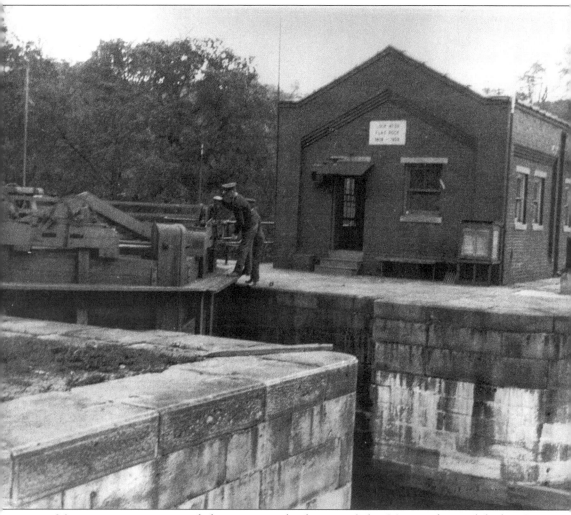

Maintaining a precarious balancing act, the keeper of the Manayunk canal locks, Capt. Winfield Scott Guiles, goes about his rigorous duty. The Manayunk canal was begun in 1819 and was completed in 1823. By 1825, the canal was in regular use. Manayunk historian Nick Myers says that Guiles, who was part Lenni Lenape, was so good at determining the weather by reading the currents of the river that Philadelphia weather forecasters would contact him on a regular basis. In the mid-1970s, Manayunk began a $1.4 million rehabilitation of the two-mile canal to restore it to its former beauty.

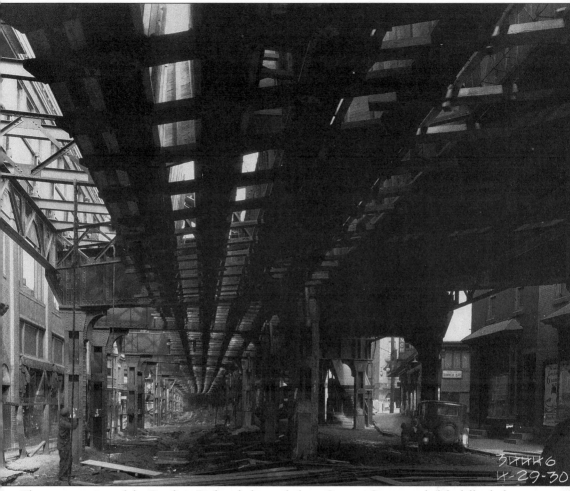

The construction of the Reading Railroad elevated along Cresson Street made life difficult for most Manayunkers, c. 1930. Designed partially to make way for automobile traffic and to decrease pedestrian injuries at train crosswalks, many thought that the raised tracks ruined the character of the town.

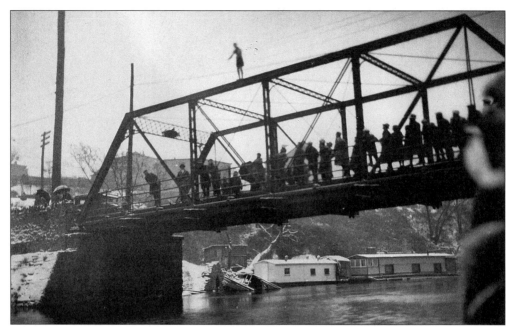

Spectators in overcoats, some carrying umbrellas, huddle together on the old Green Lane Bridge as a young Manayunk daredevil, wearing only a pair of shorts, prepares to dive or plunge into the chilly waters of the Schuylkill, *c.* 1924. Manayunk in the 1920s could be a sedate place. Many church members disapproved of playing cards, drinking, and dancing, so boys like this had to find pleasure by hook or crook.

Rockshade, a popular club near Parker Avenue, sold turkey and beer for $1 in 1930. Many small businesses and out-of-the-way shops in Manayunk also doubled as hotels. These early versions of bed-and-breakfasts even became part of warehouses and other unlikely places of business.

Looking dapper in their uniforms, these 1935 Philadelphia police officers are either pausing to contemplate the beauty of a summer's day or are on the lookout for Manayunk hooligans. After the boom in population in the 1920s, the 13th police district of Manayunk and Roxborough was restructured to include only Manayunk.

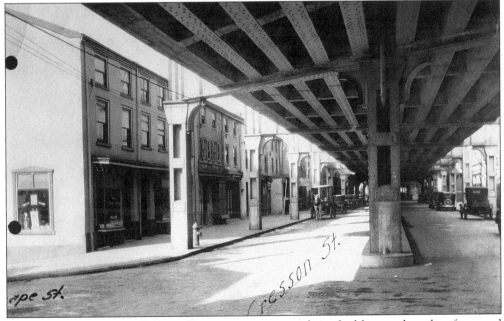

A revitalized Cresson and Grape Street intersection with its freshly paved road surfaces and just-completed elevated gave Manayunk the look of a town reborn. The horse-drawn wagon at the head of a line of automobiles on this sunny October day in 1932 recalls an earlier age.

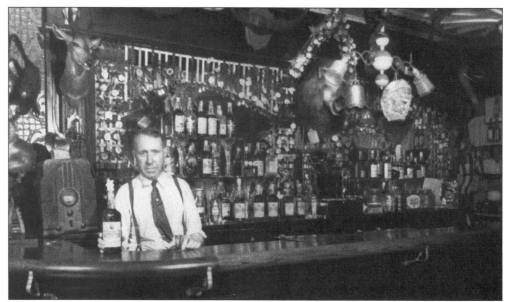

Thomas Welte's Jungle Bar at 1544 Ritchie Street was a unique Manayunk institution. It was filled with every kind of stuffed animal imaginable—rhinos, buffaloes, deer, tigers, kangaroos, and rabbits. The bar's main drawing card was when a small stuffed gorilla attached to an overhead chandelier fell onto the head of (new) unsuspecting bar patrons. According to John Kiker, Thomas Welte, the owner, (pictured c. 1930s) would pour spirits and then pull a switch behind the bar to release the gorilla. So began the initiation of the dumbfounded newcomer.

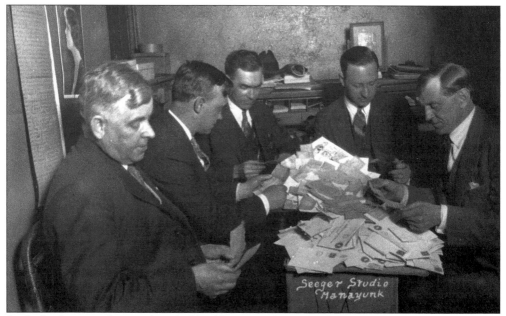

In the back room of an unidentified building, members of a club or organization—possibly the Manayunk Business Men's Association—mull over letters and ephemera c. 1927. Perhaps the gentlemen are counting ballots, deciding the winner in a town contest. Whatever was happening, we know that actress Marion Davies, whose picture is tacked to the wall, turned heads in this small room.

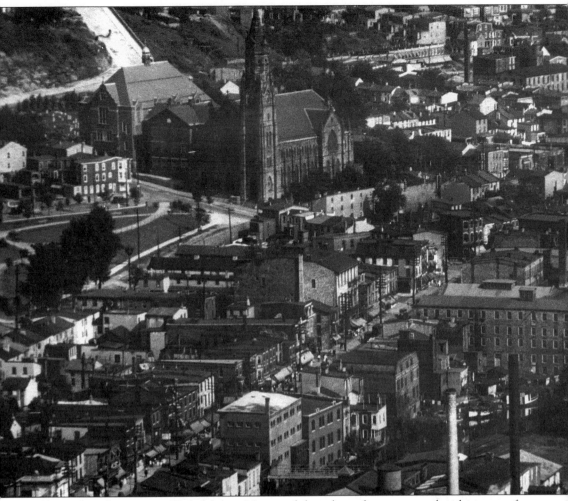

Unlike many other areas in Philadelphia, Manayunk has always been a natural melting pot of races and cultures. The church of St. John the Baptist, built in 1830 at Cresson and Rector Streets, was the first Catholic church in Manayunk. St. John's was a predominately Irish parish. The church in this pre-1920s photograph is the second church, built in 1886 and designed by architect Patrick C. Keely of New York. The first Episcopal church in Manayunk was St. David's. Established on June 13, 1832, the lot for the church was secured for $600. The church was consecrated in 1835. Prior to this, the only Episcopal services held in Philadelphia were for British soldiers who lived in trenches along the Wissahickon Creek during the Revolutionary War.

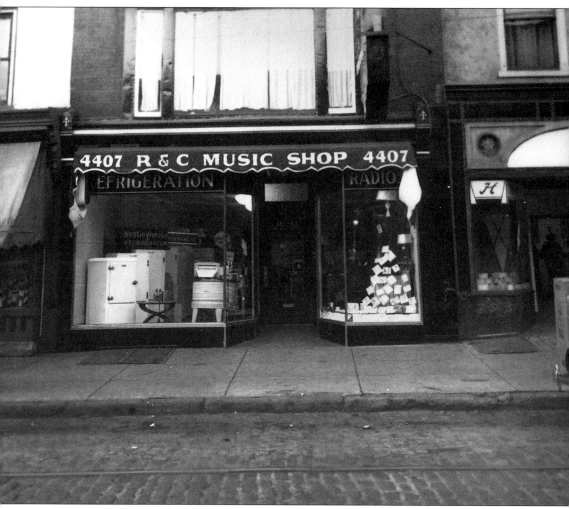

Not much is known about the R & C Music Shop at 4407 Main Street except that it seemed to be an early version of the "anything goes" household, music, and electronics store. The smiling Westinghouse man waving to potential customers points to yet another strange bedfellow: was a new washer music to Manayunk's ears? In the 1930s, the *Manayunk Review* published "Songs" by Margaret Widdemer: "Once I made the songs I sing / For—oh, anything— / For the dancing light in spring / On swift water shed / For red tulips in a row, / For some grief I did not know, / For some knight too long ago / Born and dead; / But the most of all, for one / Somewhere out beneath the sun / That I never knew . . . Now I make my songs for you."

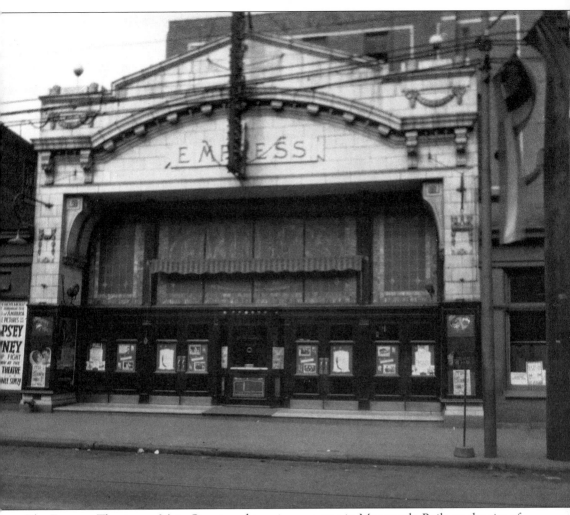

The Empress Theater on Main Street used to reign supreme in Manayunk. Built on the site of the old United States Hotel in 1914, the Empress was Manayunk's venue for "moving pictures." The theater was designed by architect Francis Hoffman and was built by James G. Doak & Company. During the 1928 dedication of the Green Lane Bridge, the Empress, with its 1,600 seating capacity, was the ceremonial hub for much of the celebration. Many Manayunkers also called the Empress the "Scratch House" because many patrons contracted lice after watching a film there. Today the grand old theater is a warehouse and garage.

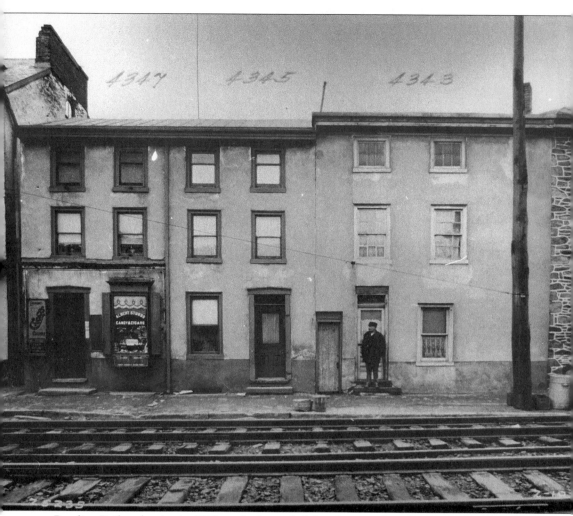

Reading Railroad trains in 1928 no doubt rattled the china in these homes as they breezed past on their way to Manayunk station. Before the construction of the elevated, automobiles often drove distances along the tracks in order to reach the homes of friends or small businesses like Albert Stubbs' Candy & Cigars. In the early 20th century, boys and girls from homes similar to these were likely candidates for domestic positions as advertised in the *Manayunk Review*. Some advertisements in 1911 read: "Wanted—A half-grown German Girl to assist in general Housework" and "Wanted—A Boy to learn blacksmith."

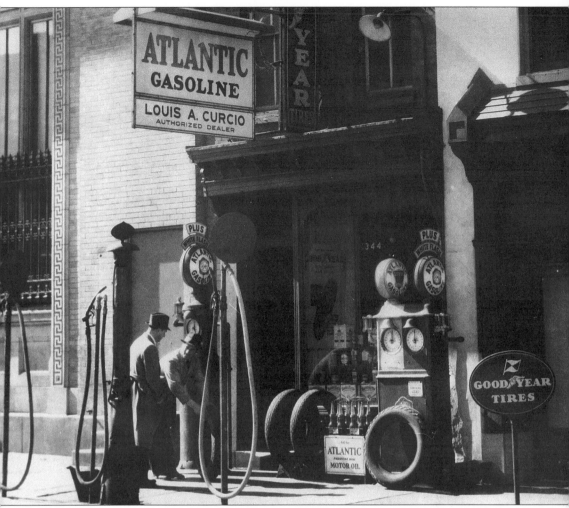

The owner of Atlantic Gasoline, Louis A. Curcio, is seen here holding a tire. In 1911, the Manayunk United Gas Improvement Company put out this bulletin: "Manayunk with its varied industries, its enormous mills, its thriving local commerce, and splendid and growing array of homes . . . stands today on the threshold of what thoughtful observers recognize as a magnificent future. . . . Not only is Gas in such general use because of its cleanliness, convenience and brilliancy, but because it is the cheapest medium as well as the best for any use to which it is put."

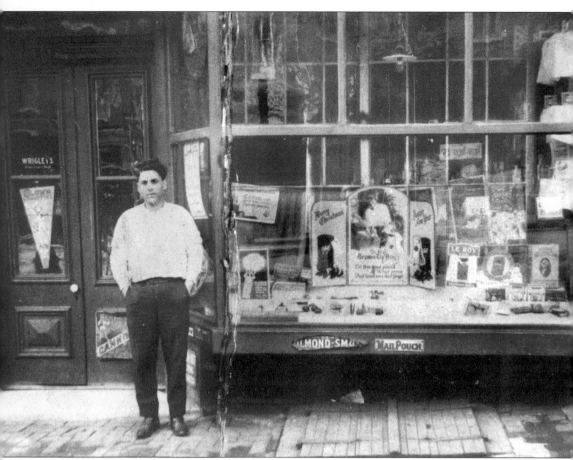

This 1920s smoke shop and variety store along Main Street braced other specialty stores like Joseph C. Morris' grocery store at 4403 Main Street, the oldest grocery in Manayunk. Morris promised his customers that his goods were of the highest quality and that the store observed "the Pure Food Laws." They sold jelly glasses for 20¢ a dozen, Parawax (for jelly glasses) at 10¢ a pound, bacon for 25¢ a jar, and Golden States Peaches for 20¢ a can. Another Morris motto was, "Absolutely Straight Spices Sold Here." The McManus Grocery at 4113 Main Street specialized in oysters for parties and receptions.

Despite the small number of Prohibition-friendly groups and churches in the area, Manayunk still had a thriving bottled spirits industry. Here employees of the L & O (Leebert & Obert) beer company in the 1930s pose with their families and children. J. Serwazi, "the Dexter Bottler" on Grape and Dexter Streets sold "pure Cabinet Whiskey" for 75¢ a quart. Father Kubienski's at 4048 Main Street was a wholesale dealer in liquors, whiskey, beer, and soda. Retail liquor stores included Kern & Kern at 4421 Baker Street, which specialized in (Philadelphia-brewed) Schmidt's beer. In the brochure for the 1909 Manayunk Carnival and Parade, the Philadelphia Pure Rye and Whiskey Distilling Company took out a half-page advertisement to attract the attention of Manayunkers.

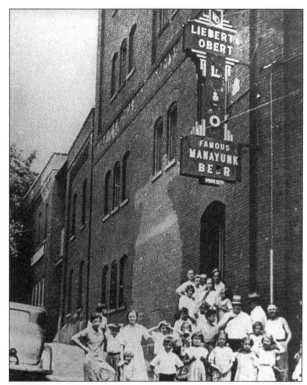

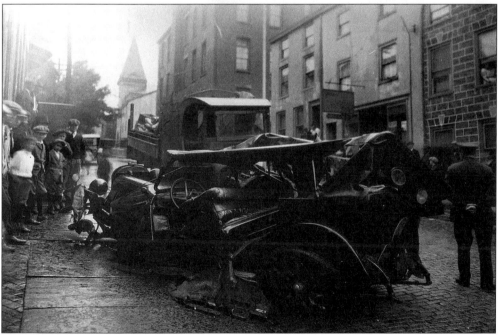

Young boys in 1929 ponder the eye of David Seeger's camera as well as the wrecked heap of car and truck on an unidentified Manayunk street. The police officer regulating traffic and overseeing the dramatic aftermath suggests that one person's traffic tragedy is another person's "traveling circus."

Marking time until adulthood is the way it is with many young men. Here two neighborhood urchins in 1927 explore the town's steep hills on their homemade go-cart, which would be no match for the town's tough cobblestoned streets if the unfortunate cart were to spin out of control. On Sundays, Manayunk pulled in the sidewalks. In 1987, the *Roxborough Review* reported that on Sundays most people at the turn of the century spent most of their time in church. "Sunday afternoons were used for reading, napping, or taking walks along the banks of the Wissahickon Creek. Picnics were a summertime habit."

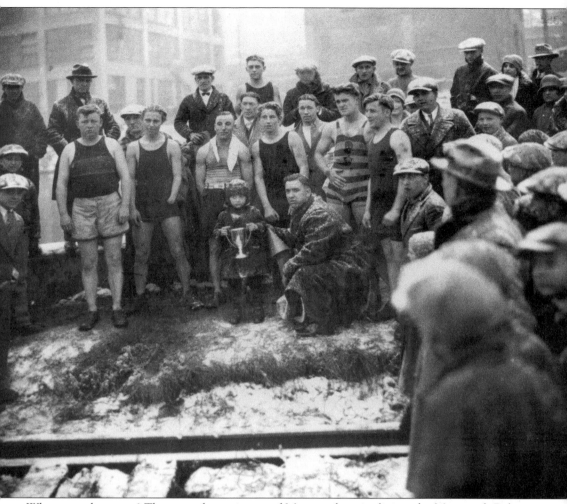

Where are they now? These tough specimens of Manayunk masculinity, the Manayunk Polar Bear Club, brave the elements in 1929 after a freezing dip in the Schuylkill River. The little boy on the far left in "Dennis the Menace" glasses seems to have hit a nerve with a wry comment or wisecrack.

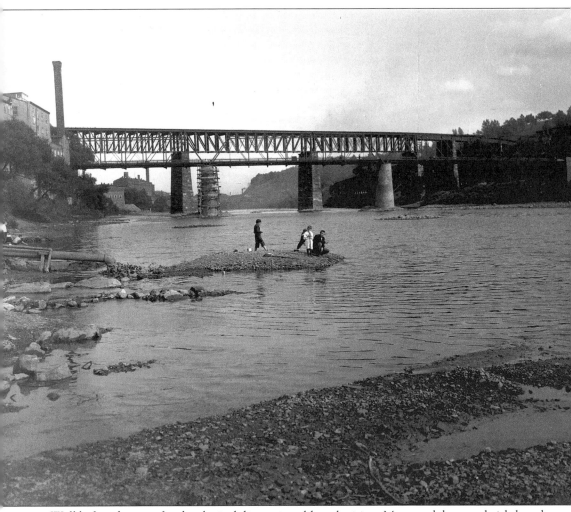

Well before the age of technological distractions like television, Manayunk boys and girls loved to play on the banks of the Schuylkill. On July 12, 1911, the *Manayunk Review* reported, "Three young men who were enjoying a canoe ride on the Schuylkill River last Wednesday afternoon had a narrow escape from drowning. Their frail boat struck a submerged rock near Flat Rick Dam and turned turtle, throwing all hands into the water. One of them, Robert Cameron, could not swim, and was rescued with difficulty by his companions, George Hillman and Edward Wharton, who were nearly exhausted when they got him ashore. Cameron received medical attention before he could be sent home."

Racing across the newly dedicated Green Lane Bridge in search of the perfect fit, ace shoe repairer F. Cherry smiles at the camera. Shoe repairers and dealers were common in Manayunk from as early as 1869. Feet were big business. There was J.N. Baer at 4405 Main Street and J. Shanefield's Reliable Sample Shoe House at 4335 Main Street. In 1911, the Forster Brothers Department Store at 4356–4368 Main Street sold women's "Queen Quality" Oxfords for $2.75. Men's Oxfords went for $3.50 and $1.90 and were made of Guu Metal, Patent Colt, and Russets, all hand-sown with welted soles.

Like something the cat dragged in, this boy sailor band on the steps at Pretzel Park in the 1930s does not look like they have spent any time at sea. The unidentified group no doubt entertained Manayunkers on holidays like Memorial Day and the Fourth of July. There is little question that Manayunk's waterways inspired the sailor motif.

The properly dressed and groomed 1930 gentleman biker looks as though he stepped out of the pages of F. Scott Fitzgerald. He may have been preparing for a leisurely excursion along the banks of the Wissahickon and an early dinner at the Valley Green Inn. In 1922, T.A. Daly, in his book *The Wissahickon*, wrote, "At most, if not all, of these roadhouses, catfish and waffles and chicken dinners were served at all seasons, and in winter when the roads were white, and not too deeply covered, trim sleighs drawn by fast steppers flashed up and down the drive from Ridge Road to Chestnut Hill; and moonlight nights, especially were all a jangle of silver bells . . . grand ladies shielding their complexions from the sun with tiny parasols . . . took the air and enjoyed the scenery with calm dignity."

Looking lonely and desolate, these buildings in 1928—possibly along Main Street—seem to point to the coming depression. Prior to the 1920s, Manayunk had known only good times, but by the early 1920s, area industries realized that there were no more expansion opportunities in the town.

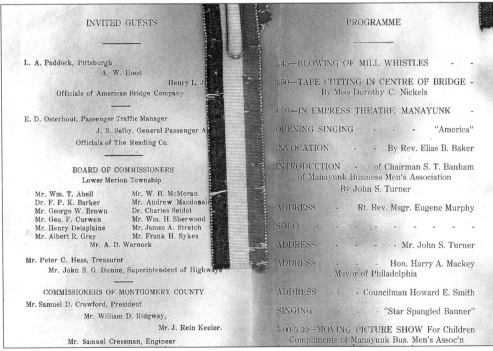

INVITED GUESTS	PROGRAMME
L. A. Paddock, Pittsburgh	3.45—BLOWING OF MILL WHISTLES - -
A. W. Hood	
Henry L. J	3.50—TAPE CUTTING IN CENTRE OF BRIDGE -
Officials of American Bridge Company	By Miss Dorothy C. Nickels
E. D. Osterhout, Passenger Traffic Manager	4.00—IN EMPRESS THEATRE, MANAYUNK -
J. S. Selby, General Passenger A	OPENING SINGING - - - "America"
Officials of The Reading Co.	
	INVOCATION - - By Rev. Elias B. Baker
BOARD OF COMMISSIONERS	INTRODUCTION - of Chairman S. T. Banham
Lower Merion Township	of Manayunk Business Men's Association
Mr. Wm. T. Abell Mr. W. H. McMoran	By John S. Turner
Dr. F. P. K. Barker Mr. Andrew Macdonal	ADDRESS - Rt. Rev. Msgr. Eugene Murphy
Mr. George W. Brown Dr. Charles Seidel	
Mr. Geo. F. Curwen Mr. Wm. H. Sherwood	SOLO - - - - - - -
Mr. Henry Delaplaine Mr. James A. Stretch	
Mr. Albert R. Gray Mr. Frank H. Sykes	ADDRESS - - - - Mr. John S. Turner
Mr. A. D. Warnock	
Mr. Peter C. Hess, Treasurer	ADDRESS - - - Hon. Harry A. Mackey
Mr. John S. G. Dunne, Superintendent of Highways	Mayor of Philadelphia
COMMISSIONERS OF MONTGOMERY COUNTY	ADDRESS - - Councilman Howard E. Smith
Mr. Samuel D. Crawford, President	SINGING - - - "Star Spangled Banner"
Mr. William D. Ridgway,	
Mr. J. Rein Keelor.	5.00-5.30—MOVING PICTURE SHOW For Children
Mr. Samuel Cressman, Engineer	Compliments of Manayunk Bus. Men's Assoc'n

This brochure was handed out during the celebration of the opening of the new bridge across the Schuylkill River (the Green Lane Bridge) on Monday, December 17, 1928.

120

Dorothy C. Nickels poses in the family garden in 1941 at 4400 Manayunk Avenue. She often told people how it was discovered that her brother John Edward became an epileptic after a fall from his father's wagon on the streets of Manayunk. For centuries it was not known that bumps to the head was a major cause of epilepsy, but when Nickels heard of an interesting new theory being offered by medical scientists at the Adelphia Hotel in downtown Philadelphia, she says she quickly boarded a trolley for the city in order to hear the "full explanation."

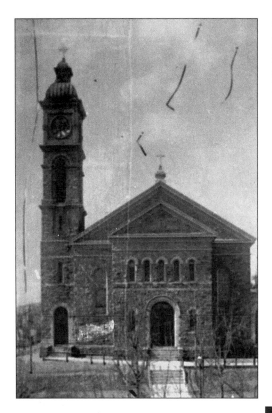

The church of the Holy Family (Irish) at Hermitage and Wilde Streets, c. 1920s, is still active. The church was founded in 1897 and was designed by architects Patrick C. Keely and Thomas Lonsdale.

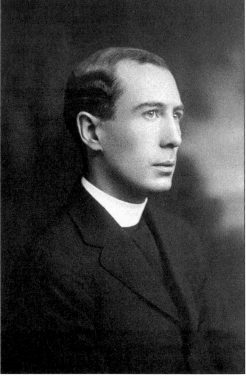

Father Fasig, assistant pastor of St. Mary of the Assumption Church on Sliverwood and Conarroe Street, is shown in this 1930s photograph. Fasig had a reputation for helping the sick and elderly. His work in Manayunk was missed when he left St. Mary's to become a pastor of a church in Pottsville. "He was a very kind man," one Manayunk woman remembers.

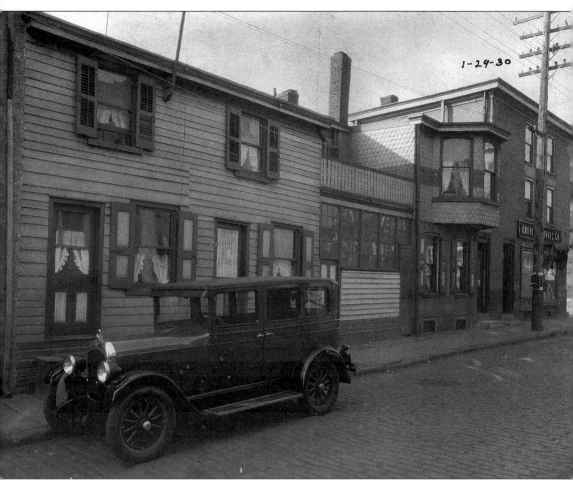

This David Seeger 1930 photograph shows the first house and store of William B. Nickels, where most of his children were born, as was the custom at the time. In 1915, when Nickels was elected president of the Manayunk Business Men's Association, the *Manayunk Review* reported that when the gavel was turned over to Nickels, "he told of his start in business when he purchased a wheelbarrow that helped him to become a successful businessman. This wheelbarrow is still in his possession, and James P. Seery wheeled it in, much to the surprise of the new president."

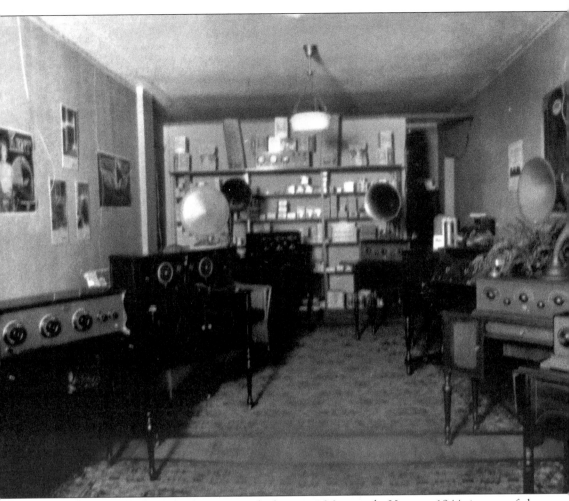

The 1940s were a twilight time in mostly forgotten Manayunk. Here, c. 1944, in one of the stores along Cresson Street, a little bit of life rears its head. Although World War II was drawing to a close, it was two years before the Philadelphia *Evening Bulletin* printed its interview with Dr. Frau Gabrielle Strecker in an article entitled "Weary German Women, Sick of War, are Seen as Influences for Peace." "German women are just as responsible as men for the rise of Hitler," Dr. Strecker said. "They were not accustomed to independent thinking and they were easily influenced by propaganda. They loved the idea of military glory for their men. Now, for the first time they have felt the destruction of war and suffered from it. They suffer more than men. The Nazi Government took all responsibility from women—now suddenly they have to think for themselves. Thousands have to earn their own living. They were taught they belonged to the master race. Now they have to take any job they can get—scrubbing floors or anything. Can you imagine the psychological effect of all this?"

Architect Frank V. Nickels poses on the lawn at his family's home with his sons Frank and Tom. Frank designed Philadelphia's Nazareth Hospital in 1939.

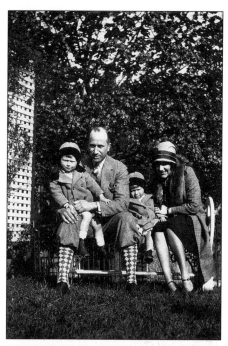

The Nickels Building was built in 1906 to house the Five Per Cent Building and Loan Association and F.W. Woolworth on the first floor. The upstairs hall was used by various groups for meetings, lectures, and banquets until *c.* 1940. The building itself changed hands many times in the 1950s, 1960s, and 1970s, until it was finally refurbished in the early 1990s to fit in with Manayunk's new look.

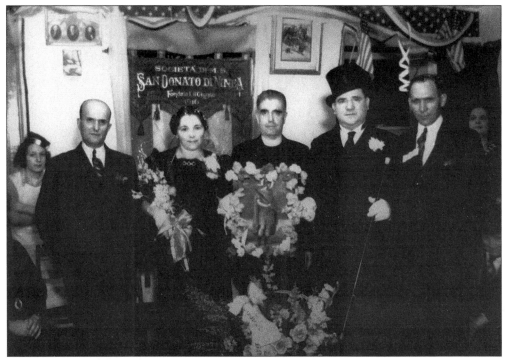

Italian Catholic parishioners from St. Lucy Church, 146 Green Lane, celebrate the feast of San Donato Di Ninea in Nickels Hall in 1916. St. Lucy was founded as a mission church in West Manayunk in 1906.

Tom and Frank Nickels sit on the lawn at 4400 Manayunk Avenue in May 1927. Tom, left, followed his father's footsteps and became an architect; brother Frank became a salesman.

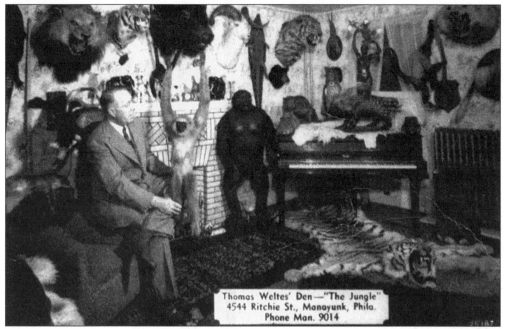

Thomas Weltes' Den—"The Jungle"
4544 Ritchie St., Manayunk, Phila.
Phone Man. 9014

Inside the Jungle Bar in the 1930s, owner Thomas Weltes surveys his cast of animal characters. Many Manayunkers today wonder what became of these fascinating wall heads.

Nickels Hall is shown as it appeared in 1992, with its "Antiques Roadshow" display of goods. The light fixtures on the ceiling are the same lamps that Charles Schofield saw when he announced the closing of all of Manayunk's mills.

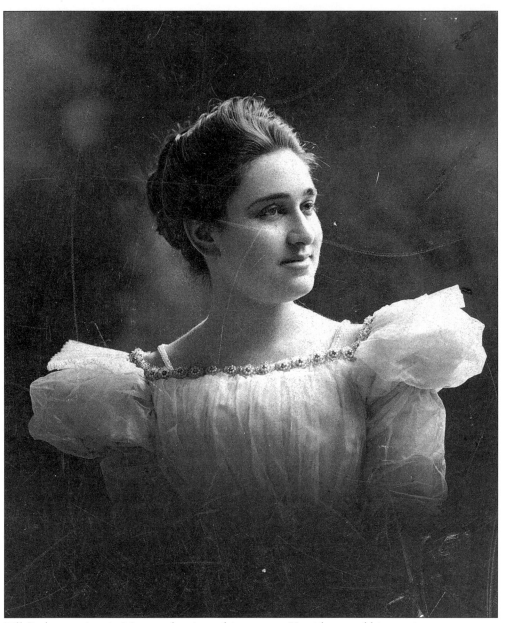

Bill Seel spent time in Manayunk prior to his move to Harrisburg and his marriage to a woman named Jane. What made that marriage so extraordinary in 1900 was its ecumenical nature: Jane was Jewish and Bill a German Catholic. Regarded as a "scandal" in those days, the couple spent years sidestepping family disapproval. In time, Seel became a very successful Harrisburg businessman; he owned a number of liquor stores and was involved in Pennsylvania Democratic politics. In a 1938 article in the *Harrisburg Evening News*, Seel was described as a "lifelong friend" of newly appointed assistant postmaster general of the United States, Ramsey S. Black. It was Seel who hosted the black tie affair in Washington's Willard Hotel. For many years, the Seels traveled the world and became collectors of art and artifacts. At the time of his death in the 1940s, Seel was one of the wealthiest men in Pennsylvania.